IMAGES
of America

KERMIT

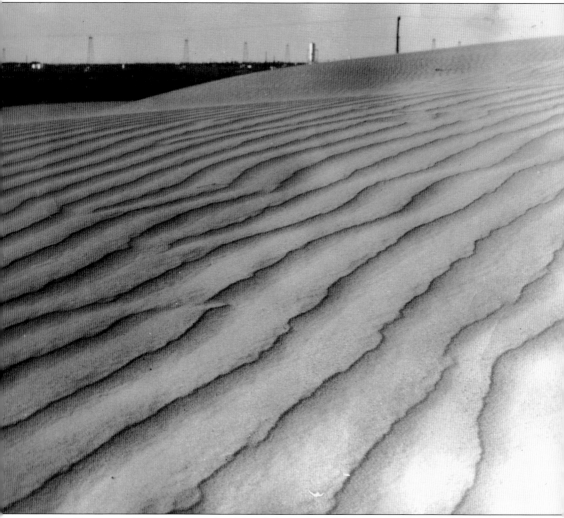

The Kermit sand hills are part of a 100-mile belt of sand that runs through Winkler County and four surrounding counties in Texas and into New Mexico. The sand hills were essential to the area's Indians as a source of water and as a hunting ground. Many of the hills rise over 70 feet high and are more recently used as a spot for riding four wheelers and dirt bikes. (Courtesy of Kenneth Edwards.)

ON THE COVER: These four contestants in the 1956 Miss Kermit pageant were sponsored by Blake Motor Company. From left to right, the women shown here in front of Winkler County Park are Connie Ingram, Ariliss Froelich, Lynda Hyatt, and Sallie Raines. The pageant was held every Labor Day as part of Kermit's Labor Day celebration. (Courtesy of Kenneth Edwards.)

IMAGES
of America

KERMIT

Kaysie L. Sabella, Kenneth Edwards,
and Betty Edwards

ARCADIA
PUBLISHING

Published by Arcadia Publishing
Charleston, South Carolina

Printed in the United States of America

Library of Congress Control Number: 2011920846

For all general information, please contact Arcadia Publishing:
Telephone 843-853-2070
Fax 843-853-0044
E-mail sales@arcadiapublishing.com
For customer service and orders:
Toll-Free 1-888-313-2665

Visit us on the Internet at www.arcadiapublishing.com

For my family, friends, and everyone who loves Kermit, Texas.

CONTENTS

FOREWORD

"When I was about six years old, I was going on my first roundup. We had to get up about four in the morning to drive to the ranch. It was a cold, cold morning. When we got there, the cook had the fire going beside the chuck wagon, so I got up close to the fire to keep warm. In a little while, I realized I needed to go to the bathroom. I looked all around, and it sure was dark and scary looking away from the fire. The longer I stood there, the worse I had to go, but I still didn't want to go off into the dark bushes. I decided I would just go where I was. As I started to undo my belt, the cook noticed what I was about to do. He yelled, "Don't you pee on my fire!" Then he walloped me on the behind with a 10-inch cast iron skillet. Believe me; you haven't been walloped until you've been walloped with a 10-inch cast iron skillet. It made such an impression, I didn't have to go to the bathroom the rest of the day."

—Story told by Bill Waddell at the Winkler County Centennial in 2010

ACKNOWLEDGMENTS

Sitting on couches, sifting through generations of family images, and discussing family and town history is how much of this book and the information provided within was obtained.

The majority of photographs were donated from Ken and Betty Edwards, coauthors of this book. All of the people who donated to the book have family histories intertwined with the history of Kermit, and I would like to honor them for their time and for sharing a love of Kermit, Texas, our common heritage.

First of all, I would like to thank my many helpers, Dorothy Parker, Bill Beckham, Bonnie Leck, Stefanie Haley, Jamarsha Ballard, and Virginia Thompson for entrusting me with your personal photographs and answering my many questions. I would also like to thank Vida Simpson for always making time for me when I would randomly drop by, and to Don and Beverly Perry for sitting with me for hours trying to pen down names, places, and dates. Finally, I would like to thank Bill and Barbara Waddell, Fred Dunlap, and Mrs. and the late Mr. Reich, who shared with me their most precious family photograph collections and information about the town and their family histories. Talking with all of you and seeing the love you have for these photographs and their history ignites my passion for this book.

I would be remiss if I did not thank my friends who always jump on board to support me: Alexis, Natalie, Brandon H., Brandon S., Amy B., Laura, and Lacey, know that y'all are truly treasured. Also, I cannot forget to include my editor, Lauren Hummer, who never failed to answer a phone call and reassure me in my efforts.

And to my family, you each contribute to my success. Thanks to my grandparents, Ken and Betty Edwards, who have been my sidekicks throughout this project; my parents, James and Judy Williams, for listening to me constantly talk about this book; my brothers Josh and Tyler for being my computer geniuses and comic relief; and to my husband, Brodie, for supporting me and reminding me to have fun.

INTRODUCTION

Sand sweeping across the plains, tumbleweeds, and cattle conjure up images of rustic cast-iron boot spurs strapped to the boots of a weather-beaten, determined cowboy. However classic these American Western images are, they are actually not far from the reality of early life in Kermit, Texas.

Before the cowboys arrived and left their mark, however, the area was inhabited by first the Anasazi Indians, then the Apache Indians, and finally the Comanche Indians, who resided in the area until the 1870s. Each of these tribes left evidence of their habitation through artifacts of pottery and pictographs in cave dwellings on Blue Mountain, also known as "The Caprock." The area was perfect for tribal survival due to ponds of fresh water that lay about two feet below the surface and an abundance of wild game.

In 1849, the US government mapped out the 100-mile sand belt that ran from New Mexico into Texas and through Winkler County. The project, completed during the California Gold Rush, was intended to aid gold-seekers and promote settlement in the West. Capt. Randolph B. Marcy brought the first military expedition into the area in 1849, searching for the best wagon route to California. Other expeditions soon followed, and in 1850, the area was carved out as part of the Texas Territorial Compromise. Texas gave up a third of its land when it was annexed to the United States in 1846. In return for the land, Texas received $10 million from the US government, which was mostly used to pay off debts incurred by the former Republic of Texas. The new boundary, named the 32nd parallel, was located just north of Kermit, Texas, and separated Winkler County from New Mexico.

After the Texas Territorial Compromise was settled, an 1854 expedition led by Bvt. Capt. John Pope was sent to survey the 32nd parallel as a possible railway route. The Comanche continued to inhabit the area until 1875, when Col. William R. Shafter tracked them and Col. Ranald S. Mackenzie helped remove them from the area by 1876. The area was officially safe for settlement, and the establishment of the Texas and Pacific Railway in 1881 in nearby Ward County made the area accessible.

The Texas policy of free use of public land was still active, and settlers started moving into the area and established small farms and large ranches. Settlers were starting to spot the landscape, so in 1887, the Texas Legislature decided to create six new counties out of the vast territory of Tom Green County; one of these was named Winkler County for Confederate war hero Col. Clinton M. Winkler.

Small towns such as Duval, Joiel, Theodore, Hay Flat, and Kermit began to spring up all over the area. Kermit was named after Pres. Theodore Roosevelt's son Kermit, an avid hunter who had visited the T Bar Ranch located in the northern part of Winkler County. Kermit, like many other small West Texas towns of that time, was created to serve as a central supply hub for ranchers living in the isolated area. The area did not boom overnight; instead, it grew slowly, and settlers carved out huge plots of land for their ranches. The Cowden brothers, Doc, Tom, and Walter, were among the first to establish ranches. Another early rancher, T.M. Waddell, bought Doc

Cowden's land in 1906. Remarkably, T.M.'s ranch, one of the first in Winkler County history, is still in working order today and has remained in the Waddell family for over 100 years.

The state ended its free land use policy in 1900. That year, a census listed 12 ranches in the county, which, combined, covered 67,537 acres. Much of the land had been saved by the state and designated as school land, but in 1901, Texas implemented a law that allowed the sale of school land, and this began a school-land rush in West Texas. The law did have stipulations; each eligible person could only homestead four sections, the land was sold on a 40-year plan at three-percent interest, and settlers had to live on the land for three years before they could acquire the title to it. In 1905, the law changed once again—this time, the land was sold to the highest bidder. New settlers moved into the area, and many post offices opened up in small towns throughout the county.

A competition for the title of county seat soon emerged between the towns of Duval and Kermit. Duval opened up a post office in 1908 and strongly promoted its town lots in an effort to win the title, but Kermit won the seat after it offered free lots and increased the town's population. Winkler County was officially organized on April 5, 1910, and four precincts were established. Among the first county commissioners was T.M. Waddell, one of the first ranchers in the area, elected for Precinct Three. The early ranchers further helped the establishment of Kermit by building the county's first courthouse, public school, and post office in 1910. After Kermit was named the Winkler County seat, the other small towns slowly faded away.

Life in Kermit was steady up until 1916, when a drought hit the area and forced many settlers to abandon their homesteads. The drought had a devastating effect on the population and by 1924, only one family, Ern Baird's, lived in town; only one student, Louise Baird, attended school for five months in 1924. With the town almost completely abandoned, the public school and the post office were moved into the courthouse and remained there through 1926.

A new era of prosperity arrived on July 16, 1926, in the form of oil, discovered on Thomas G. and Ada Hendrick's land just outside of Kermit. The T.G. Hendrick Ranch was a sprawling 30,000-acre ranch, and about 3,049 feet below its surface lay a 10,000-acre pond of oil. The discovery of "black gold" caught the attention of other oil companies, and soon a new industry had moved into the area. The Hendrick well was finally plugged in 1939, but not before it had produced 235,000 barrels of oil. The boom not only stimulated the growth of Kermit's population, but it also created a new town, Wink, situated to the west.

While open-range ranching was still a viable industry, most of the land in the area was already homesteaded, so the majority of the new population was drawn to the territory because of the rich oil fields. In 1927, a census listed Kermit's population at 1,000; by 1929, the population had risen again to 1,500. In March 1929, newcomers found it easier to get to Kermit due to the establishment of the Texas-New Mexico Railway, which passed through town. A new courthouse was needed after the discovery of oil, so a four-story structure was built in 1929 right beside the 1910 courthouse.

The 1930s were a time of unsettling population decreases and increases until a 1940s oil boom quickly caused the entire area to transform. People flooded into Kermit and Wink, trying to find work. Real estate prices doubled, and a lack of housing forced people to live in tents. More children meant a bigger school had to be built; more workers gave rise to the area's first hospital.

The boom lasted throughout the 1960s; by now, natural gas was also a staple area industry. The Kermit area went from a population of 1,500 in 1929 to a population of 10,465 in the 1960s. The town was at its peak, boasting 260 businesses. On September 5, 1960, Winkler County citizens celebrated their semicentennial Golden Jubilee celebration where they buried a time capsule on the courthouse lawn, which was to be opened in 2010.

More recently, the town's population has fluctuated with the prices and demand for gas, but the 2000 US Census counted a population at 6,153. Along with the decline in population, the need for updated educational facilities arose, and a project to combine two elementary schools into one facility was under way. Kermit Elementary School opened in 2009, replacing East Primary Elementary, which had educated students in pre-kindergarten through second grade, and Purple

Sage Elementary, where third grade through fifth grade had been taught. The new elementary school was built beside Purple Sage Elementary. A project to replace the 1950 Kermit High School and build a new high school was also approved, and it is currently being built in the area once occupied by East Primary Elementary.

The 1947 Winkler County Memorial Hospital was also replaced with a more sophisticated facility in 2008. The landscape around Kermit was further altered in 2008 when wind turbines found a home on top of Blue Mountain, "The Caprock."

Winkler County celebrated its centennial in 2010, and on September 25 of that year, the 1960 time capsule was excavated. A new capsule was buried in the same spot and is scheduled to be opened in 2060. Most of the county's residents came out to celebrate the history of the area and to be a part of history themselves.

This book tells Kermit's history through the eyes of people who experienced its twists and turns, from the early ranching days through the dangerous oil fields to the town's heyday. It also provides a special look at the lives of individuals who made Kermit their home and their history.

One

RANCHING

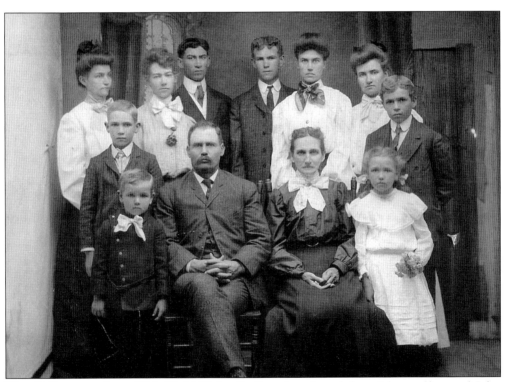

This 1905 picture shows T.M. Waddell's family. Seen here from left to right are (first row) John Monroe Waddell, Thomas Monroe Waddell, Annie Eliza Holcombe Waddell, and Nona Ruth Waddell; (second row) James Millican Waddell and William Ashbury Waddell; (third row) Barbara Alameda Waddell, Mary Stella Waddell, George Frank Waddell, Richard Thomas "Cotton" Waddell, Ella Carolyn Waddell, and Dora Ann Waddell. (Courtesy of Barbara Waddell.)

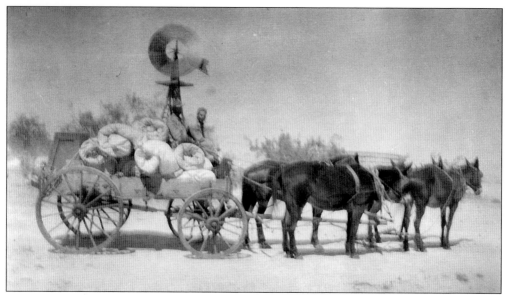

This chuck wagon is loaded with the cowboys' bedrolls. Pictured here around 1937 are Jim Waddell (left) and Martin Nichols. These rolls were two-inch thick mattresses with fitted sheets (made by their wives), a blanket, and a waterproof cover. The entire roll was then secured by two belts. These bedrolls were heavy; it took two men to load them into the wagon. (Courtesy of Bill Waddell.)

Jim Waddell was the son of ranch founder T.M. Waddell. Many of Jim's siblings sold their interest in the ranch to the brothers and sisters who wanted to run it after T.M. died in 1913. By 1949, the ranch was divided into three parts: one third was owned by J.F. Fernandes, husband of Dora Ann Waddell, and the other two-thirds by R.T. and J.M. Waddell. (Courtesy of Barbara Waddell.)

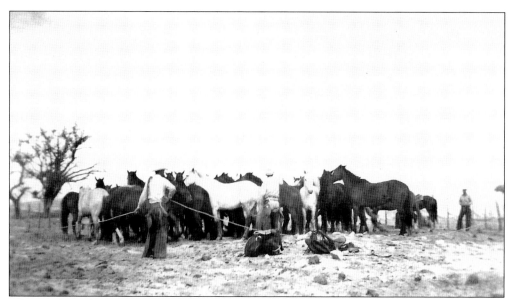

After making the Baird Drive, the cowboys needed fresh horses, so they made a corral out of rope—their only alternative in an area that offered no pens, corrals, or chutes. R.T. "Cotton" Waddell is doing the roping here. (Courtesy of Bill Waddell.)

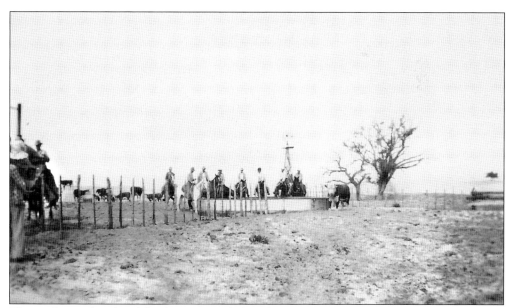

The cowboys take a break by the watering hole. The ranch was divided into multiple areas, each of which had its own watering hole. The cowboys had to herd the cattle to a new area periodically to give the grass time to grow back. Many of the cowboys seen here are Waddell family members, but a few are hired hands. (Courtesy of Barbara Waddell.)

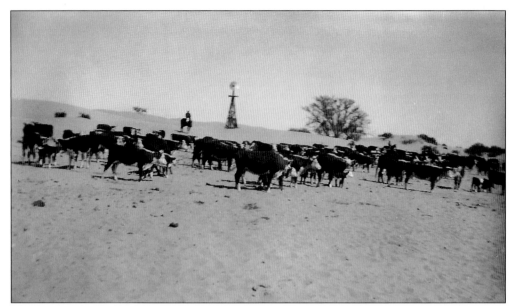

This herd of cattle is moving across the sandy plains on the Waddell brothers' ranch. The cattle knew that the windmill is where they go to get water. All areas of the ranch could be indicated by using its section and block. A section was made up of approximately 640 acres. The original Waddell ranch, begun in 1906, was comprised of 54 sections, but that number has changed over time and generations. (Courtesy of Bill Waddell.)

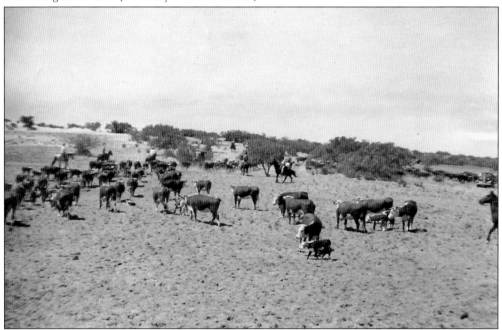

These cowboys have just finished branding the cattle and are taking the herd to water to turn them loose. The cattle brands have changed over the years for the Waddell family, along with the name of the ranch. The most recent brand is "06," which represents the 100 years of ranching by the Waddells, and is associated with the outfit's newest name, the Waddell Homestead Ranch. (Courtesy of Barbara Waddell.)

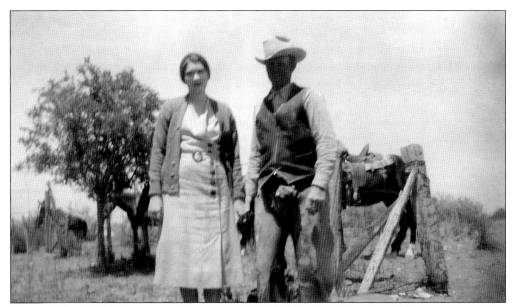

Ann and Jim Waddell were partial owners of Waddell Brothers Ranch, which was renamed the Waddell Cattle Company. After Jim passed away in 1965, Ann did not sell her interest in the ranch. Instead, she remained a partner and operated the Waddell Homestead Ranch with her children, Bill Waddell and Lolisa Waddell Laenger, until she passed away on December 16, 2007. (Courtesy of Bill Waddell.)

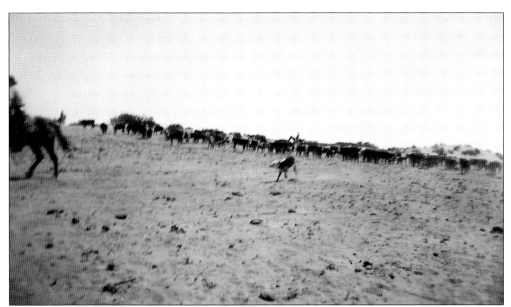

Driving the cattle across the sprawling Waddell ranch required many skilled cowboys. These cowboys relied heavily on the abilities of their horses, which were thoroughly trained to react to the shifts of the cattle and the directions of the rider. These horses were the cowboys' most useful tool when driving cattle. (Courtesy of Barbara Waddell.)

In these photographs, Jim Waddell is breaking a horse—the first step in training a horse. Jim liked to train cutting horses, horses that could cut a single animal from the herd and keep them away. These horses were especially useful on a ranch when riders needed to separate a calf from its mother. Jim had one horse, named Agate, who loved to cut so much that he would cut a chicken away from the rest of the flock so that Jim could catch it for dinner. (Both, courtesy of Bill Waddell.)

The Waddell family not only raised cattle and trained horses, but they also bred horses. Between 1914 and 1915, the ranch bought a horse from the US Army named Little Kingfisher, who was one of the original quarter horse lines going back to Steel Dust, one of the foundation horses of the American Quarter Horse breed. In order to buy Little Kingfisher, the Waddells also had to buy all of the mares. The Waddell ranch gained a reputation for breeding these outstanding horses and attracted a number of buyers. One of these buyers was Will Rogers. Unfortunately, he was unable to collect his horse when a plane crash ended his life. However, after Will Rogers passed away, his family did take possession of the horse. (Both, courtesy of Barbara Waddell.)

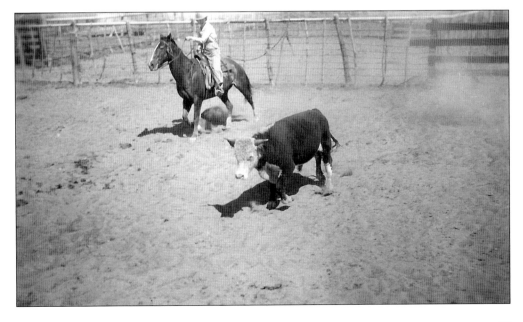

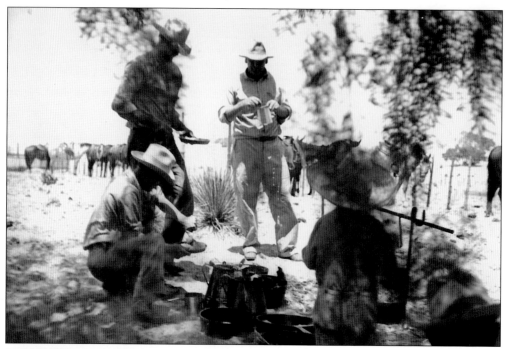

These cowboys are gathered around the campsite about to eat a meal. During cattle drives, a cook was brought along to prepare the meals. The iconic image of cowboys sitting around a campfire eating beans from a can is not quite accurate. The cook would prepare filling meals such as chicken-fried steak because the cowboys worked long hours and needed hearty sustenance. (Courtesy of Bill Waddell.)

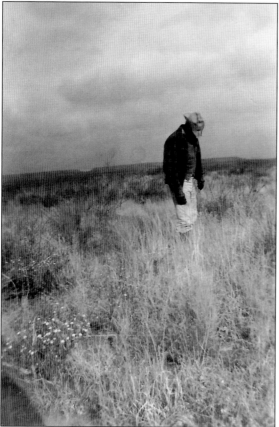

Jim Waddell is shown surveying the grass on the Waddell Cattle Company ranch. He is inspecting a seed head. The grass he is in is excellent sandy land grass found in the northwest corner of the middle pasture. This photograph was taken in December 1947. While the grass in West Texas takes longer to grow, it contains more protein, which is excellent nourishment for the herd. (Courtesy of Bill Waddell.)

The cowboys had to cut this cow from the herd. They also had to rope, throw down, and tie this cow so that they could trim its hooves. The hooves needed to be trimmed because cows that range in the sand tend to grow long hooves that can sometimes look like paddles; trimming the hooves can help the cow get around better. (Courtesy of Barbara Waddell.)

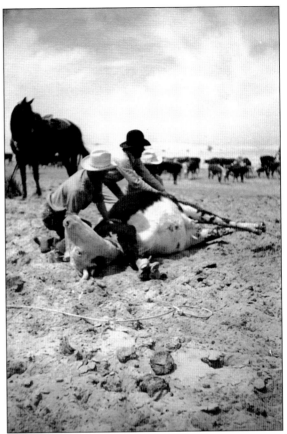

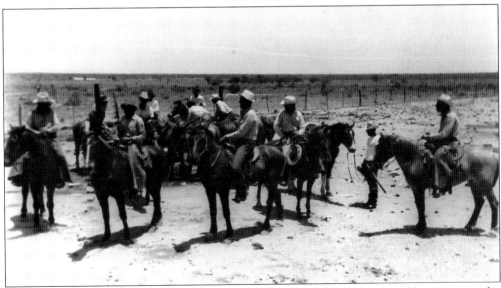

These cowboys are getting ready to go on a cattle drive. While cowboy hats and boots are popular attire, they actually serve a purpose. Many of the cowboys are wearing chaps, which will help keep their legs safe from brush, such as the mesquite trees that are prevalent in the area, and wide-brimmed hats will protect their faces and necks from the sun. (Courtesy of Bill Waddell.)

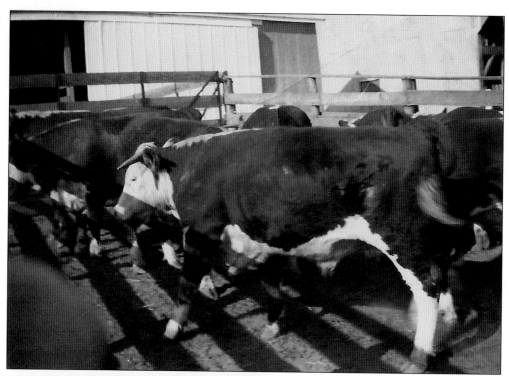

The Waddell steers are seen here on the home scale lot. The steers are of the Hereford breed, which became very popular in the United States and especially in Texas due to their durability. The Hereford breed is very tough, which made it ideal to withstand the dry conditions of West Texas. The cattle also mature early and grow very large, which makes the breed more desirable. (Courtesy of Barbara Waddell.)

Like his father T.M. Waddell, J.M. (Jim) Waddell served as the county commissioner for Precinct Three. He served four separate terms, the last in 1935–1936. In the early days of Winkler County, the Waddell Ranch House was the polling place for Precinct Three. Jim was a member of the Kermit School Board, was elected tax assessor in 1923, and was active in church and other civic functions. (Courtesy of Bill Waddell.)

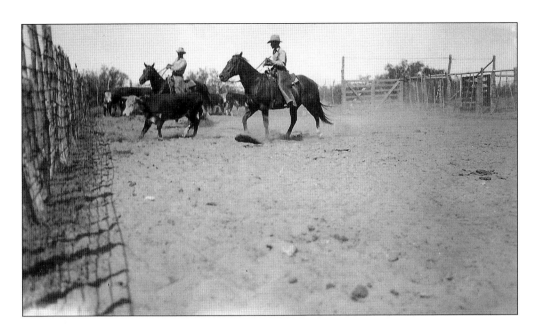

Both of these pictures show cowboys working the cattle. In the photograph below, Bill Waddell is third from the left, and Mark Lambert (Bill's son-in-law) is second from the left. While the Waddell family is mostly a ranching family, they have dabbled in farming. In 1908, the Waddells grew watermelons, one weighing 100 pounds. In 1912, George W. Waddell, T.M. Waddell's brother, planted 14 acres of cotton, which yielded three bales. Later, J.M. Waddell's brother Frank planted sugarcane, which grew into the biggest field of cane Jim had ever seen, and all of this farming was done without the aid of irrigation. (Both, courtesy of Barbara Waddell.)

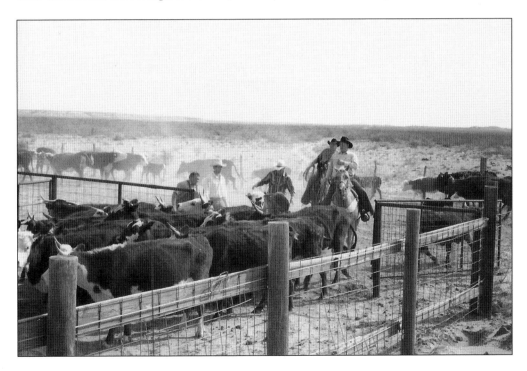

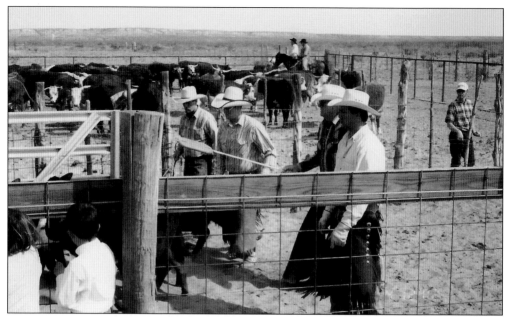

From left to right, James Waddell (son of Bill and Barbara Waddell), an unidentified cowboy, Bill Waddell (owner), and Mark Lambert (Bill's son-n-law) separate the calves from the herd. The calves have to be branded and tagged before they can be released back to the herd. It is important to keep track of the calves in order to prevent inbreeding. (Courtesy of Bill Waddell.)

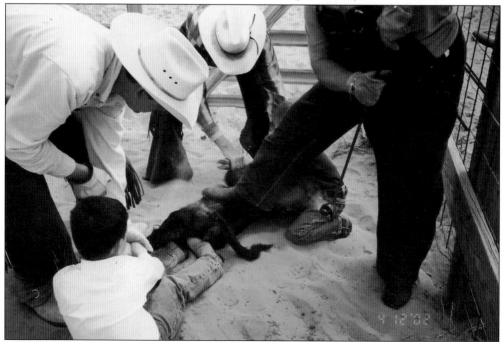

Mark and his son Deric Lambert hold the back legs and Bill and his grandson Jake Waddell restrain the front legs while Milton Thompson brands the calf with the Waddell Homestead Ranch brand, "06." Bill Waddell is passing on over 100 years of ranching knowledge to his grandchildren. (Courtesy of Barbara Waddell.)

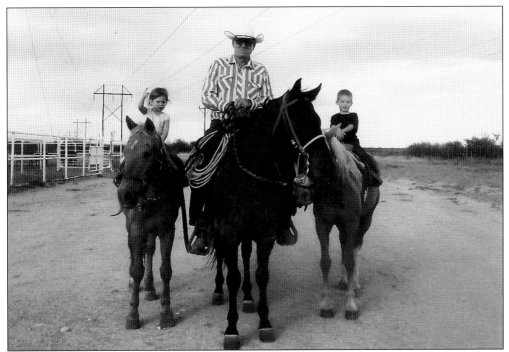

Bill Waddell rides his horse, Cowboy, in between his grandchildren. From left to right, they are Brenna Waddell (daughter of James and Vickie Waddell), Bill Waddell, and Justin Waddell (son of James and Vickie Waddell). Brenna started riding horses when she was two-and-a-half years old. Ranching is not a job for the Waddell family, it is a way of life. (Courtesy of Bill Waddell.)

In this image, the whole family is helping to work the cattle. James Waddell (son of Bill and Barbara Waddell) is pictured with his head down. The grandchildren of Bill and Barbara Waddell are pictured on the fence. From left to right are Deric, Brittney, Jared, and Jake. (Courtesy of Barbara Waddell.)

Barbara and Bill Waddell's grandchildren are ready to ride their horses with their grandfather Bill. The grandkids are, from left to right, Shelby Waddell (daughter of James Waddell); Rebbekah, Brittney, and Deric Lambert (children of Shannon Waddell Lambert and Mark Lambert); Jake Waddell (son of James Waddell); and Justin and Brenna Waddell (children of James and Vickie Waddell). (Courtesy of Bill Waddell.)

The Waddell family took this most recent picture in 2006. From left to right are (first row) Mark Lambert, Shannon Waddell Lambert, Brenna Waddell, Ann Waddell Countryman, Justin Waddell, Vickie Waddell, and James Waddell; (second row) Deric Lambert, Brittney Lambert, and Barbara Waddell; (third row) Rebbekah Lambert, Lolisa Waddell Moores Franklin Laenger, Chuck Laenger, Greg Moores, Margrit Moores, Bill Waddell, Shelby Waddell, Silas Moores, and Jake Waddell. (Courtesy of Barbara Waddell.)

In the photograph at right, Bill Waddell and ranch hand Ricky Heady repair a windmill. The Waddell Homestead Ranch has recently installed solar panels in order to use the sun instead of the wind to pump the ranch's water. Using solar power actually conserves water because it does not pump too much water on a windy day. The new technology is very useful because wasting water in the desert can be hazardous for the cattle. Bill Waddell still needs to periodically check on the pumps to make sure that everything is working properly, but the solar technology has proven more efficient. (Both, courtesy of Bill Waddell.)

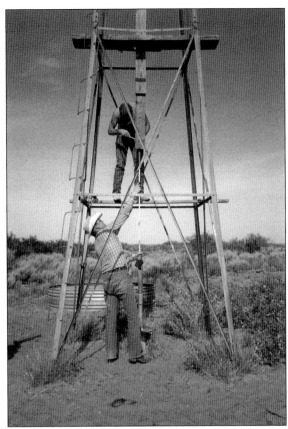

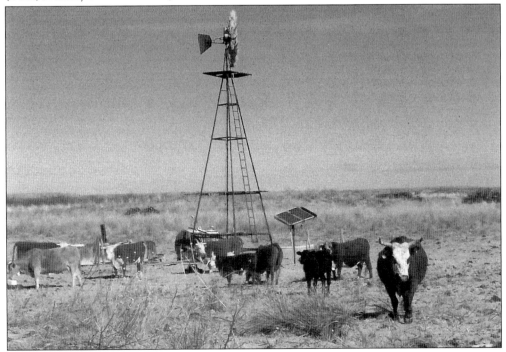

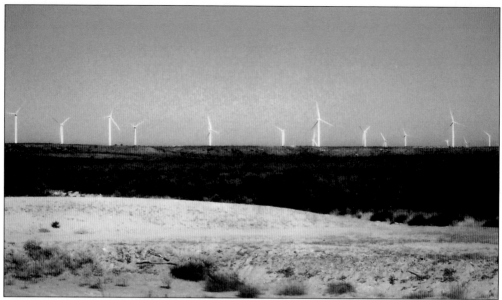

Solar power may have arrived on the ranch, but wind power is not forgotten. Eighteen wind turbines were placed atop Blue Mountain on the Waddell Homestead Ranch on April 1, 2008. These turbines were not the first energy-producing mechanisms on the ranch, however. In the mid-1950s, the Waddells leased some of their land for oil production. (Courtesy of Barbara Waddell.)

Having celebrated 100 years of ranching in 2006, the Waddell family continues the tradition today. The ranch itself was originally known as T.M. Waddell and Sons, and then divided and given many different names such as J.F. Fernandes and Sons, Waddell Brothers and Company, Waddell Cattle Company, and Waddell Homestead Ranch. Though many names and brands make up the Waddell legacy, the entire original ranch is still owned by descendants of T.M. Waddell. (Courtesy of Bill Waddell.)

John Alva "Papa" Haley founded the Haley Ranch in Loving County in 1915. J.A. Haley moved his wife, Julia, and son John Furman to the ranch. In 1926, the Haleys bought the Oates Ranch, which was located in Winkler County by this time. Most of the land had been homesteaded, so buying from individual sellers was necessary. (Courtesy of Stefanie Haley.)

This photograph of Julia "Momma" Haley, wife of John Alva Haley and mother of John Furman and J. Evetts Haley, was taken when she was about 60 years old. After she died, her sons split up the ranch. (Courtesy of Stefanie Haley.)

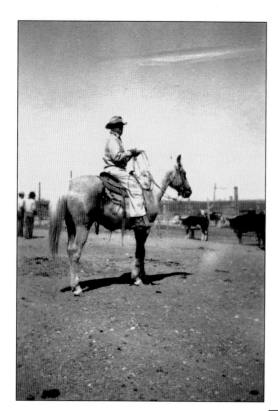

John Furman Haley, married to Florence Haley and father of Gene and John Haley, is pictured working cattle. After the ranch was split, John Furman Haley received a big part of the ranch in Loving County and the Oates homeplace. J. Evetts got the center of the ranch. J. Evetts had one son, J. Evetts Jr. (Courtesy of Stefanie Haley.)

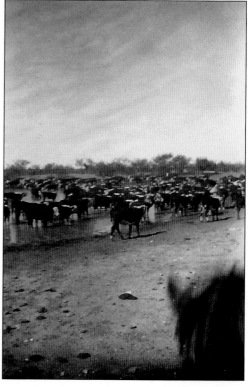

The cattle are at the watering hole. The shallow water table supported the cattle in this dry area. The Haleys, like the Waddells, also raised Hereford cattle, which were durable cattle for the dry climate. Also, like the Waddell ranch, all of the Haley ranch land is still run by descendants of the original owner. (Courtesy of Stefanie Haley.)

John and Gene Haley, sons of John Furman Haley and grandsons of John Alva and Julia Haley, are pictured on the Haley ranch around 1940. All three sections of the Haley ranch are being run by Haley descendants: Ann Mitchell, Chris Haley, and Nita Haley run the Oates homeplace; Evetts Haley Jr. and his children run the middle ranch, and Mary Haley Thomas and John Edgar Haley run the oldest part of the ranch, which is located in Loving County. (Courtesy of Stefanie Haley.)

John Arthur Haley, husband to Stefanie Haley, is pictured sitting on his horse in the early 1950s. Brother to Gene, John Haley inherited the ranch's Loving County land when his father John Furman passed away. His part of the ranch is now maintained by his children, Mary Haley Thomas and John Edgar Haley. (Courtesy of Stefanie Haley.)

Robert "Gene" Haley, husband to Darby Haley, is pictured sitting on his horse in the early 1950s. After his father, John Furman Haley, passed away, Gene received the Oates homeplace, which is located in Winkler County. Since Gene passed away, his children, Ann Mitchell, Chris Haley, and Nita Haley now operate the ranch. (Courtesy of Stefanie Haley.)

Two

OIL AND GAS

Oil arrived in Winkler County, and subsequently Kermit, in 1926 due to a 10,000-acre underground oil pond discovered on ranch land owned by Thomas G. and Ada Hendrick. The well became known as the Winkler County Discovery Well. This photograph shows a drilling rig outside of Kermit. In all, 612 wells were drilled on the Hendrick Field, and the area became known as "Wildcatters' Graveyard." (Courtesy of Kenneth Edwards.)

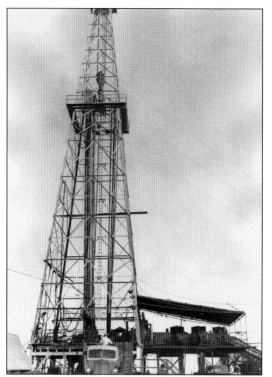

These pictures show a 1940s oil rig in Keystone Field. A drilling rig would take between two and three weeks to set up in the 1940s; now a rig can be assembled in 24 hours. The picture at left shows the oil derrick with the crown at the top. The crown houses the pulleys for the drilling rig. The tower-like structure, also known as the derrick, includes an area where a worker can walk out and work the pipe into stands so that the drilling bits can be changed. The picture below details the substructure of the drilling rig. The substructure houses the rotary table, "draw works," and doghouse. The doghouse is where workers can change their clothes and where paperwork can be completed. (Both, courtesy of Kenneth Edwards.)

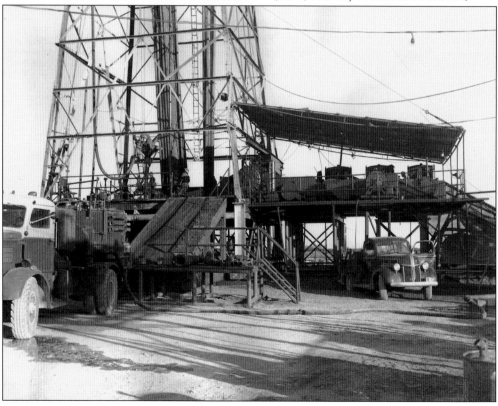

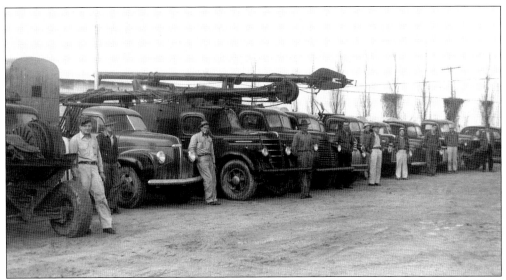

The 1940s winch trucks shown here were essential tools when setting up drilling rigs and building and servicing pump jacks. They were one of the only devices able to lift several tons of steel, which made them ideal when setting up the weights and main gearbox of a pump jack. (Courtesy of Kenneth Edwards.)

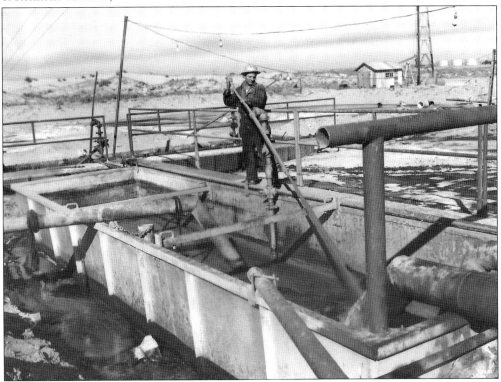

A 1940s oil field worker mixes up the mud in the steel mud pit located beside a drilling rig. Mud mixed with gel and Barite make up the drilling fluid that is pumped into the hole. The pressure and the density of the fluid help form solid walls that keep the hole from collapsing; the fluid also helps to bring up rocks and earth. (Courtesy of Kenneth Edwards.)

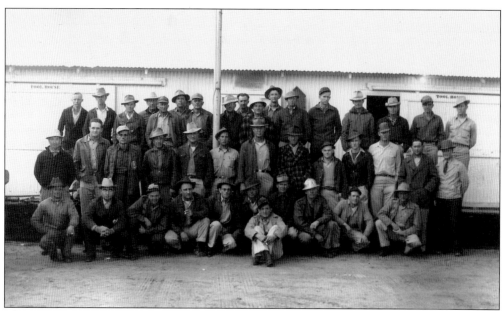

These 1940s pictures were taken at two of the various oil and gas plants around Kermit—most likely the Magnolia Plant (above) and the Sid Richardson Plant. The names of these workers are unidentified, probably because there were so many workers moving in and out of Kermit for work. Some workers died on the job because the work was hard and the oil field was a truly dangerous place and still is today. One predominant feature of these pictures is the lack of a female presence. The oil and gas industry in Kermit, Texas, was almost exclusively a male profession and remained that way until the 1970s. Even today, few women actually work in the oil field; most female employees of oil companies work in administrative positions. (Both, courtesy of Kenneth Edwards.)

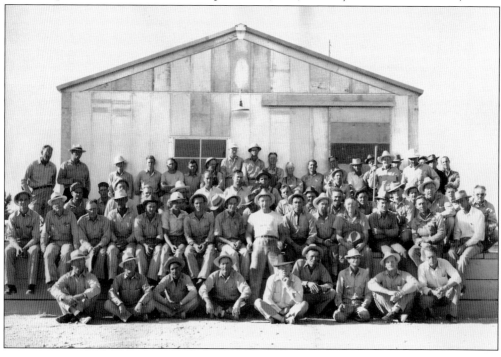

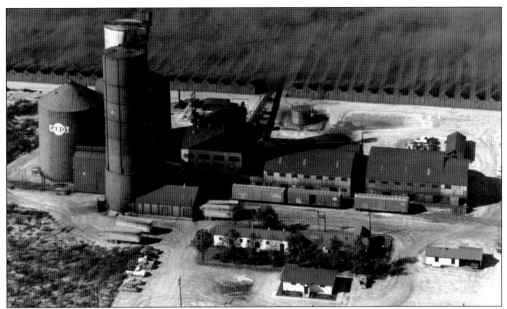

Located outside of Kermit, the Cabot Carbon Black Plant is shown here in the 1940s. Carbon black is a product reduced from natural gas that was used in the production of tires, pencils, cosmetics, and more. Some of the carbon would escape from the steel shack, where the temperature would rise to around 140 degrees, so a plume of black smoke could always be seen rising from the plant. (Courtesy of Kenneth Edwards.)

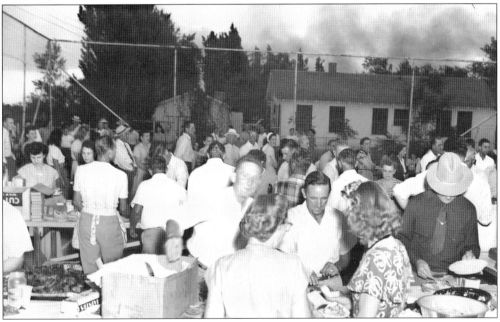

Considering the cloud of black smoke seen rising behind the neighborhood, this picnic was most likely held near the Cabot Carbon Black Plant. In the 1940s, most companies would build houses about three blocks from their plants for employees and their families. Most of the houses had two bedrooms; the few three-bedroom homes were reserved for the bosses. (Courtesy of Kenneth Edwards.)

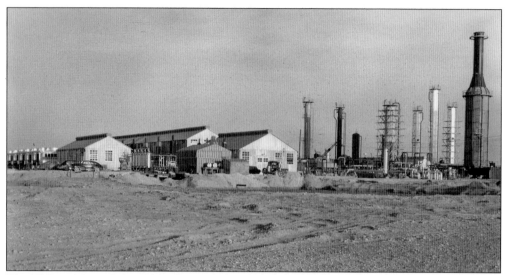

The El Paso Natural Gas Plant located just outside of Kermit is shown above, while the Sid Richardson Plant is pictured below. It was only a short time after oil was discovered that natural gas also became an industry in the area. Natural gas can be found in oil wells; sometimes it is separate from the oil, and other times they are mixed. Natural gas plants separate the gas from the oil, if needed, and separate out other gases that can be harmful to humans such as hydrogen sulfide and carbon dioxide. The gas is transported from the well to the plant through a series of underground pipelines, which can be damaged and cause explosions. (Both, courtesy of Kenneth Edwards.)

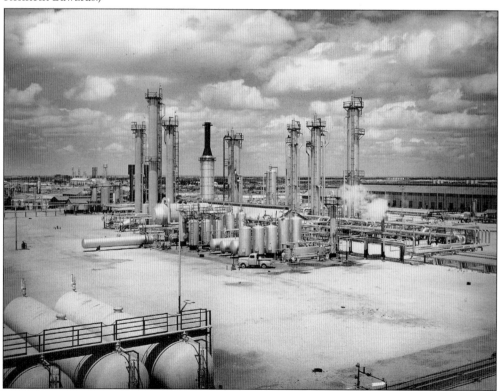

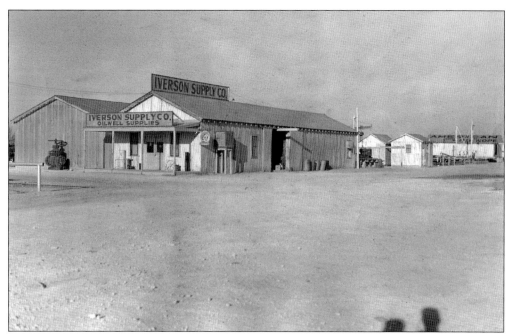

This picture of the Iverson Supply Company was taken in the 1950s. Iverson supplied oil-well products such as lubricants, pipes, and tools—anything that was necessary for the oil field industry. Companies similar to this one still operate in the area because oil and gas production has remained the number-one industry in West Texas. (Courtesy of Betty Edwards.)

Pictured at right, a "roughneck" working for United Oil Well Service Company takes a break on the back of a winch truck. The term roughneck is commonly used to refer to any worker in the oil fields. Other titles such as driller or derrick hand more specifically refer to a worker's actual job description. (Courtesy of Kenneth Edwards.)

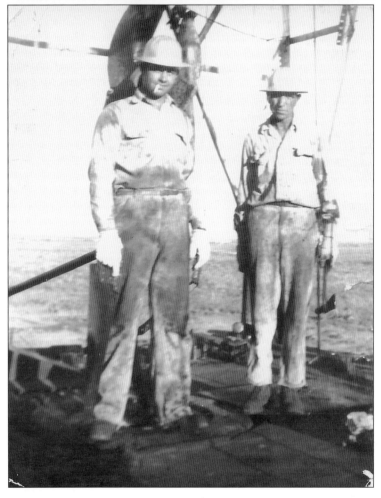

Shown above are, from left to right, four unidentified roughnecks and Nick Huda. The picture at left shows Junior Bowden (left) and Nick Huda working on a drilling rig in 1951. While Nick Huda was cleaning the subfloor of the rig with a steam hose, someone accidentally hit a valve, which caused the pressure to build until steam exploded out of the hose. Nick shot 50 feet in the air and was then brought back down, but he managed to hold onto the hose so that no one else got hurt. Luckily, he walked away with only an injured shoulder. (Both, courtesy of Kenneth Edwards.)

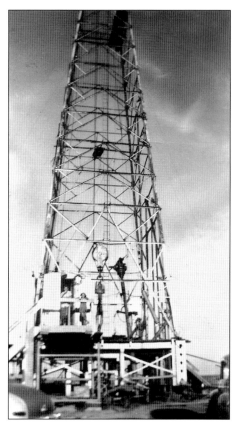

Standard Derrick 100 National Rig, named for its manufacturer, is shown here in 1951. New wells are constantly being drilled to keep up with the demand for oil and natural gas. Although it is dangerous, the job has become much safer in the last 20 years, thanks to the efforts of the oil and gas companies. Innovative safety and training programs, such as the "Lock Out, Tag Out Program" and mandatory drug testing, help to keep workers safe. The "Lock" program requires every valve to be locked, and each person's lock is placed on a valve key lockbox. In order for the key to be removed, every person first must remove his lock from the lockbox. While it seems time consuming, this program prevents people from being accidentally hit with gas. (Both, courtesy of Kenneth Edwards.)

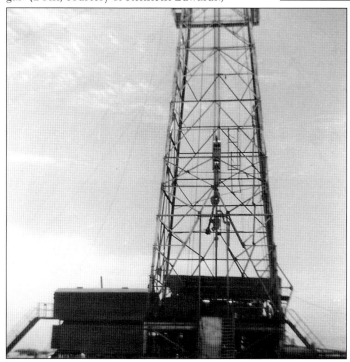

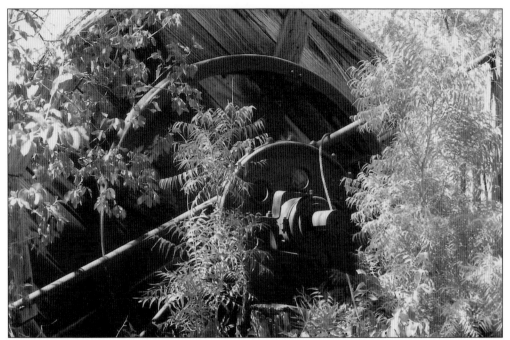

These are the remains of the drilled Moorehead No. 1, the last wooden oil derrick to retire. Donated to the City of Kermit by R.O. Moorehead in 1966 and located at Pioneer Park in Kermit, Texas, this derrick was a monument to the oil industry. The Moorehead Derrick was revolutionary for its time and has features such as bull rigs and rig irons that represent its 1920s heritage. The rig was moved from its lease in Loving County without being disassembled. After many years of use and exposure to the elements, the derrick fell apart, and these are a few of the remains. (Both, courtesy of Betty Edwards.)

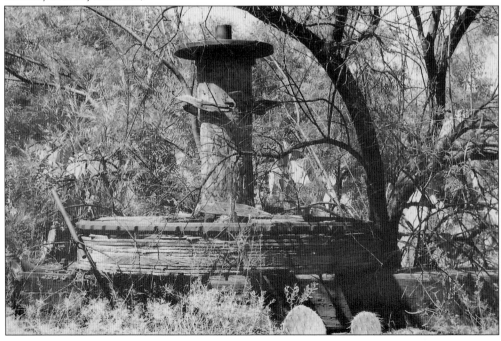

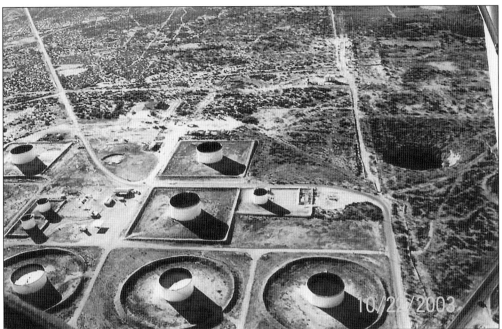

The oil industry has not only had an economic effect on Kermit, but it has also had some environmental effects. Two sink holes have formed between the towns of Kermit and Wink; the first one formed in 1980 while the second did not form until 2002. Geologists have examined these formations and estimated that underground aquifers used plugged oil wells to move and the fresh water dissolved salt deposits, causing the ground to sink. As evidence, the Hendrick well No. 10-A, drilled in 1928, was located at the site of the first sinkhole. The second sinkhole is also located on Hendrick land. Oil and gas companies are keeping a close eye on the unstable area. A tank farm is located near one of the holes and eventually may need to be relocated. (Both, courtesy of Vida Simpson.)

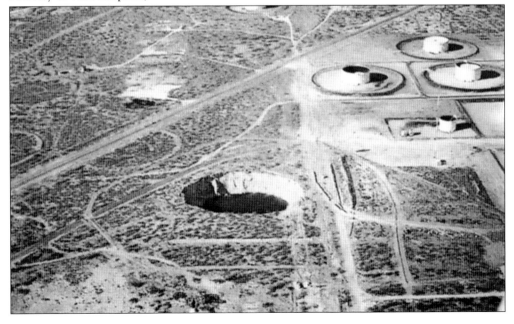

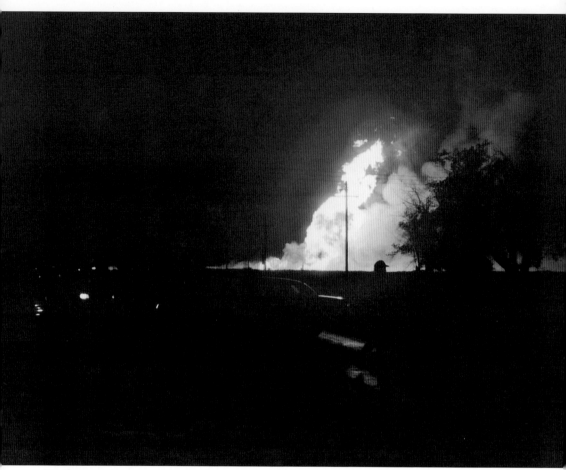

Pipeline explosions are an unfortunate reality in West Texas. The picture above shows an explosion that happened in a turbine station outside of Kermit, Texas. While scenarios such as bad pipes, exceeding MOP (maximum operating pressure), and human error can cause a pipeline to explode, the most common factor is corrosion. Pipeline corrosion is an unending process, but gas companies use a variety of techniques to combat this force of nature. The most common techniques for preventing and identifying corrosion are chemical injectors, rectifiers, anodes, and the use of pig lines. A smart pig, equipped with a camera, is run through the pipes and can show any anomalies in the pipe. If the smart pig shows that the inside of the pipe drastically decreases in size, it is probably because the pipe is corroded and needs to be replaced. Natural gas companies are proactive in using these methods because pipeline explosions are costly incidents. (Courtesy of Kenneth Edwards.)

Three

AROUND TOWN

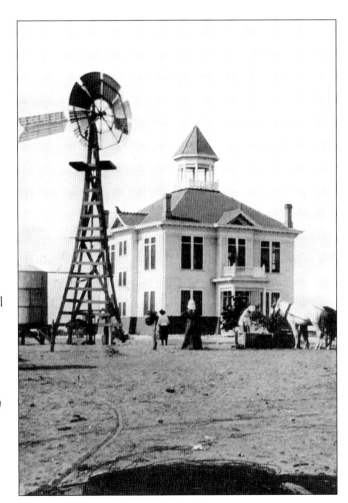

This is a picture of the original Winkler County courthouse built in Kermit in 1910. The courthouse was built the same year that Kermit became the county seat of Winkler County. On September 27, 1910, voters approved a $6,000 bond to build the courthouse; only one person voted against it. The windmill was installed in 1911 to provide water for the courthouse and horses. (Courtesy of Betty Edwards.)

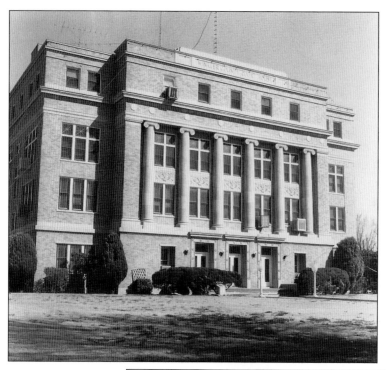

The 1929 courthouse was built to accommodate the county's growing population. After a petition for injunction against the new courthouse was presented by Wink citizens and denied, the new courthouse was built directly beside the 1910 courthouse. The courthouse was a four-story brick structure that had an addition built on in 1954. The top level was used as the county jail up until 1995. (Courtesy of Betty Edwards.)

The Community Church originally met in the 1910 courthouse after they bought it from the county for $1. Later, a new church building was proposed, and funds were raised by the congregation. One of the older ranching families, the Walton family, doubled each donation, taking less than 30 days to collect almost $30,000. The present church building, shown at right, was completed in 1938. (Courtesy of Betty Edwards.)

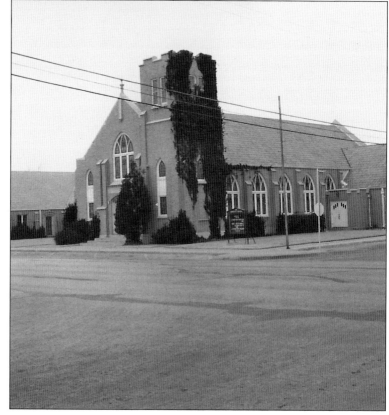

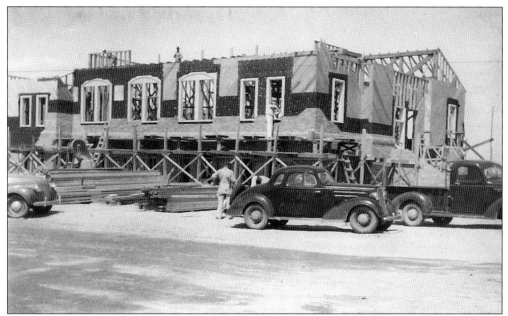

First Baptist Church of Kermit, which was organized in 1936, built on land donated by the Waddell family. The picture above was taken during the construction of the church, while the picture below shows the finished building. This building is still the First Baptist Church; however, it looks slightly different today because the front was remodeled to include columns. An annex was added in the 1940s, and another rancher, J.B. Walton, donated money for a fellowship hall, which was built in the 1950s. A fire broke out in the basement in the mid-1960s; fortunately, the building was saved and repaired. (Both, courtesy of Kenneth Edwards.)

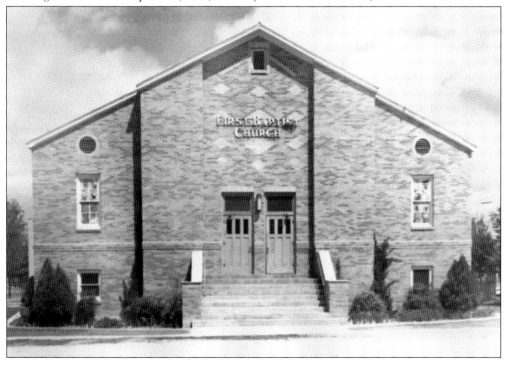

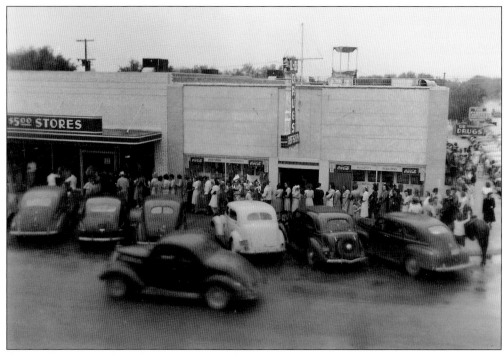

Pictured here is a Wacker's variety store, which opened in Kermit in the 1940s. Wacker's was one of many stores to make their way into Kermit during the 1940s oil boom. New oil and gas companies such as the Cabot Carbon Black plant brought new employees into the area, which helped Kermit attract new stores to the area. The opening of Wacker's caused so much excitement that the line stretched all the way around the L-B Drugs store next door. The picture above illustrates the popularity of the opening; the photograph below shows the crowded interior of the store. A shopper could find anything at Wacker's, from household necessities such as lamps, pots, and pans to more novel items such as switchblades, which were popular with teenage boys. (Both, courtesy of Kenneth Edwards.)

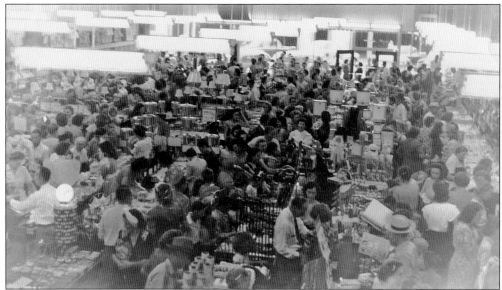

The Sid Holmes Food Store was a smaller grocery located on West Austin Street beside the rebuilt Texan Movie Theater in the 1940s. It was also directly across the street from T.M. Moore Dry Goods and Best Drug. Sid Holmes Food Store went out of business in the 1950s when larger grocery stores moved into town. (Courtesy of Kenneth Edwards.)

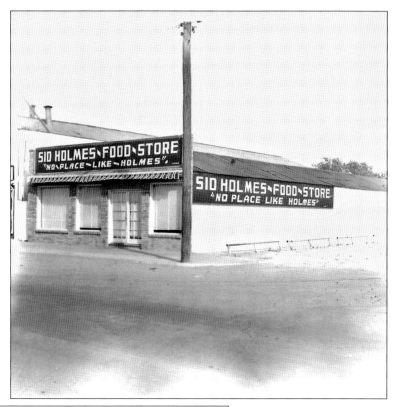

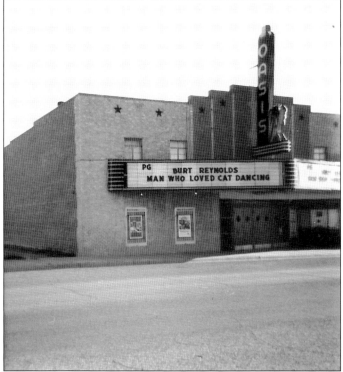

The Oasis was the third movie theater in Kermit; this picture was taken in 1973. The first theater was the Texan, and the second was the Kermit Theater. In the 1950s, a ticket cost 9¢, and many of the kids would combine their money to purchase one ticket, and then the kid with the ticket would let his or her friends in through the back door. (Courtesy of Kenneth Edwards.)

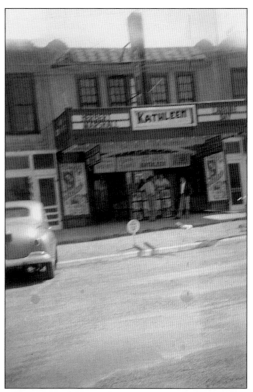

The Kermit Theater is shown at right in 1941 promoting the movie *Kathleen*, starring Herbert Marshall, Laraine Day, and Shirley Temple as Kathleen. The photograph below shows the Kermit in 1946 when it was promoting the classic Western, *My Darling Clementine*, starring Linda Darnell and Henry Fonda as Wyatt Earp. The Texan movie theater thrived during the 1930s, until the extremely flammable film caught fire in the projection booth in 1937, burning down an entire block. While Kermit once maintained three movie theaters, disasters and a decrease in population closed all three. There are no longer any movie theaters in Kermit. (Both, courtesy of Kenneth Edwards.)

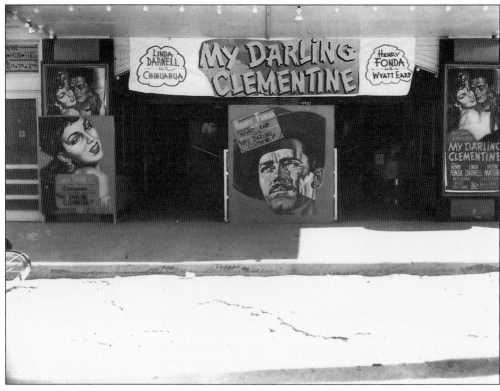

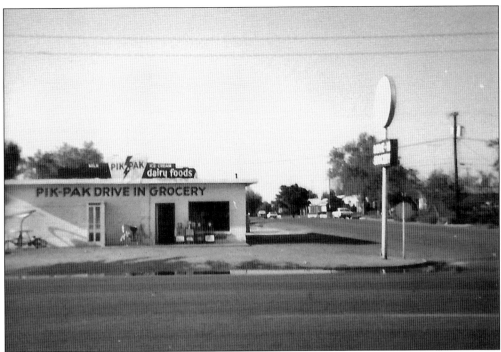

The Pik-Pak was originated in Kermit by a local entrepreneur named Neb Williams. This photograph shows the third Pik-Pak in Kermit. Pik-Pak stores were grocery stores that were about the size of a modern convenience store; they even contained a butcher shop. Other Pik-Paks were located in the nearby towns of Goldsmith, Monahans, Balmorhea, Andrews, and Pecos. Later, the Pik-Pak chain was acquired by Town and Country. (Courtesy of Kenneth Edwards.)

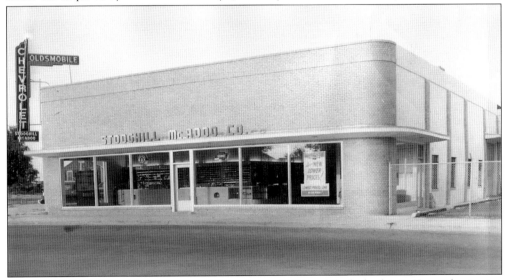

The Stodghill McAdoo Company was a Chevrolet and Oldsmobile dealership in Kermit beginning in 1949. B.M. Stodghill was a partner in the dealership until he died in 1960. His son Charles helped to run the family business until it was sold in 1974. The dealership is no longer in operation, but the building remains and so does the empty parking lot where the cars were parked. (Courtesy of Kenneth Edwards.)

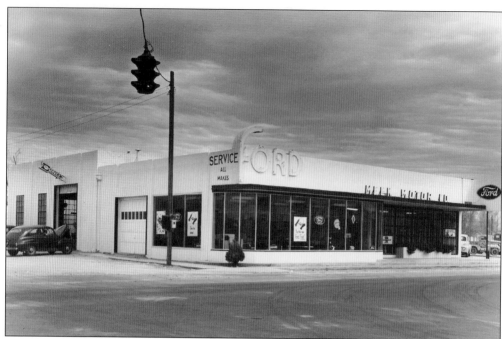

The Meek Motor Company is seen here in 1950. This is the only Ford dealership that has ever operated in Kermit. B.F. Meek bought the dealership from Jack Mays near the end of World War II and ran it until 1964, when he sold it to L.R. "Red" Nutt. The dealership was eventually passed down from Red to his son Layne Nutt, the current owner. The Ford Motor Company, as it is now named, is the only car dealership that has survived in Kermit through the bust, and it remains in operation to this day, while many other dealerships have long been out of business. (Both, courtesy of Kenneth Edwards.)

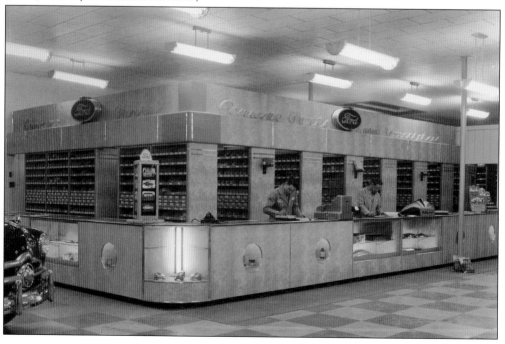

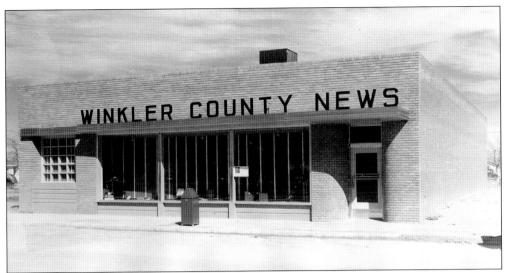

The *Winkler County News*, located at 109 South Poplar Street, opened in 1948, but the newspaper began long before this building was erected. The original owner was James L. Dow in 1936, and it is currently owned by Bill Beckham. The *Winkler County News* had to beat out a number of other newspapers, including the *Winkler Sun* and the *Kermit Daily Sun*, to survive. (Courtesy of Kenneth Edwards.)

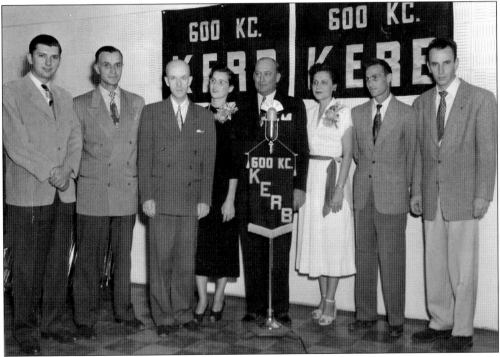

Seen here is the staff of KERB, Winkler County's first and only radio station. George Cook, the founder of KERB, rented out the back of the L-B Drugs store on Austin Street and put the station on the air in 1950. The station's disc jockeys even played music by the Wink Westerns, a local group from nearby Wink, fronted by young singer/guitarist Roy Orbison. (Courtesy of Kenneth Edwards.)

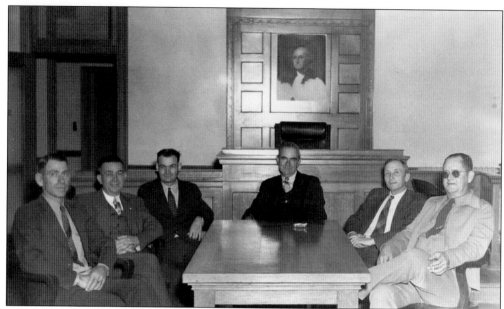

The Winkler County Commissioner's Court is made up of elected county commissioners, each representing one of Winkler County's precincts, a county judge, and a county clerk. The court meets twice a month to manage county business such as the budget; upkeep of the county parks, roads, and hospital; and much more. (Courtesy of Kenneth Edwards.)

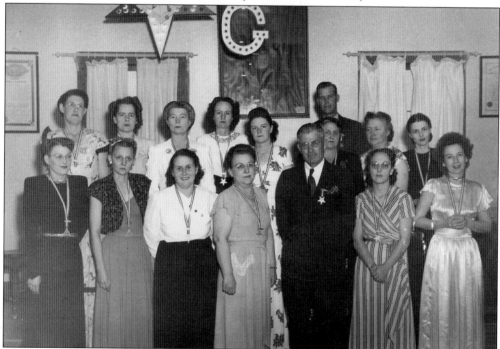

Eastern Stars, an organization founded by the Masons, is based on the belief in a higher power. The group stands for morality, and its lessons are based upon scripture. As a prerequisite for membership into this organization, a man must be a Master Mason in good standing. A woman had to be the daughter, wife, sister, or female relative of a Mason for admission. (Courtesy of Kenneth Edwards.)

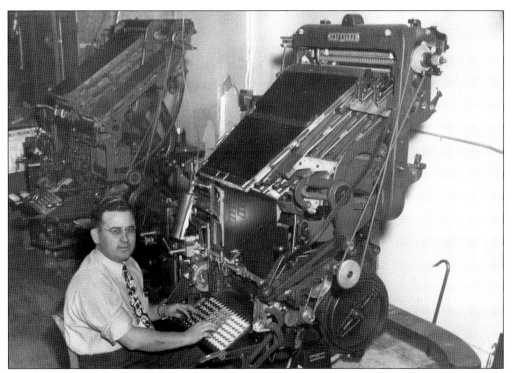

Fred Pearson bought Kermit Office Machines in 1962. Its machines were used to make multiple copies such as wedding invitations. Pearson was elected Kermit's mayor in 1948, was a member of the volunteer fire department, a city councilman, and a member of the Lions Club and many other organizations. Though Pearson donated most of his time to Kermit, he operated the print shop until he died. (Courtesy of Kenneth Edwards.)

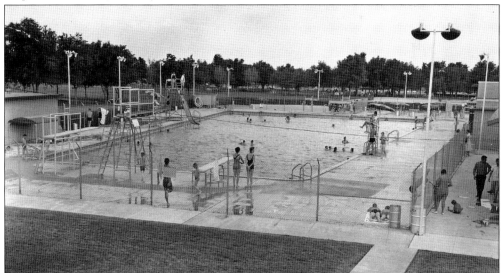

The Winkler County Pool in Kermit was part of a 30-acre project completed in 1954. Located at the Winkler County Park along with a playground, volleyball courts, gymnastic equipment, two baseball fields, a recreation center, and a nice picnic area, the AAU-standard swimming pool became the heart of summer activities for Kermit children. (Courtesy of Kenneth Edwards.)

Originally located in the courthouse, the library began in 1939, spurred by members of the Wink Study Club. The small library soon outgrew its home, and new libraries were set up in Kermit and Wink. Kermit's library was opened on September 19, 1948; Mrs. Fred Hard Wright was the librarian at this time, but she gave up her title to Rose Legrande in 1954. The library once again outgrew its home, and an addition was added to the library in 1963, which doubled the space. The library has been updated with computers for its guests and maintains a summer reading club for children. (Both, courtesy of Betty Edwards.)

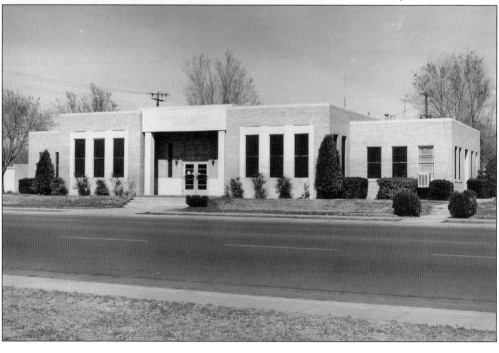

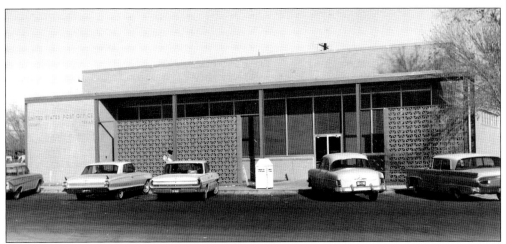

The first post office in Winkler County opened in 1908 in Duval, on a ranch owned by John Howe. Mail was delivered there twice weekly until 1910, when Kermit won the title of county seat. A new post office was opened in Kermit but moved into the courthouse from 1924 to 1926 due to a devastating drought, which reduced the population greatly. Pictured above is the current post office. (Courtesy of Kenneth Edwards.)

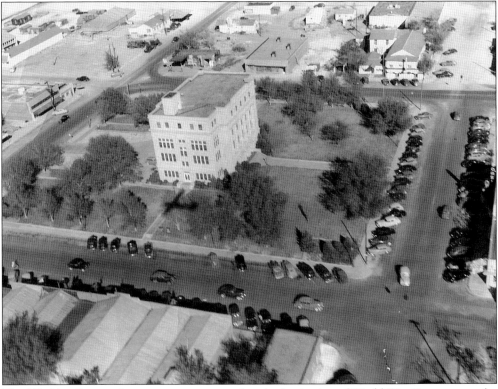

The Winkler County Airport was constructed at the beginning of World War II to support the Pyote Army Air Base. Located closer to Wink, the airport houses the weather station, which is why Wink's temperatures are reported on the news instead of Kermit's. The airport's proximity has provided the area with opportunities for great aerial photographs such as this one taken of central Kermit. (Courtesy of Kenneth Edwards.)

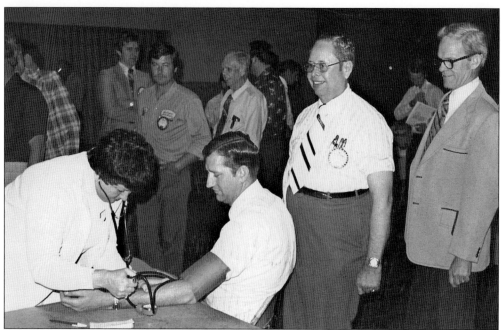

Members of the Kermit Downtown Lions Club are standing in line to get health screenings. The Kermit Downtown Lions Club was chartered in 1936 and originally had only 30 members. The Lions Club is a service organization that volunteers and raises money for important projects. They also provide scholarships to selected Kermit graduates. (Courtesy of Kenneth Edwards.)

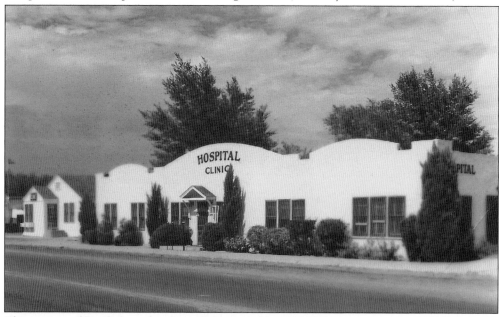

This picture of Dr. C.A. and L. Rose Robinson's Hospital Clinic was taken in 1939. Robinson's was one of many doctor-owned hospitals located in Kermit before the county hospital was built. Other hospitals, such as Dr. Samuel Hurst Stewart's Kermit General Hospital, also operated in Kermit. After the Winkler County Memorial Hospital was built, the Robinsons stayed in business but only operated as a clinic. (Courtesy of Kenneth Edwards.)

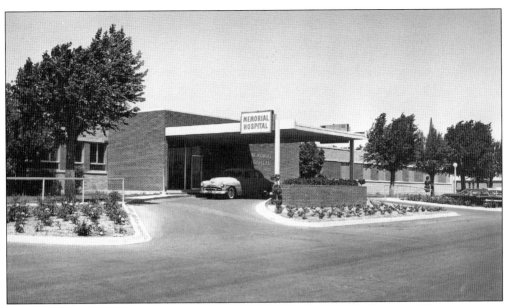

The above picture shows the entrance to the original Winkler County Memorial Hospital, which officially opened on June 13, 1948. Dr. C.A. and Rose Robinson worked for the county hospital along with operating their own clinic. The hospital has seen many alterations over the years: it added 20 patient rooms in 1954 and a new business office in 1962, and its name changed to Memorial Hospital in 1966. The picture below shows the length of the front of the hospital in the 1950s. Memorial Hospital even hosted licensed nursing classes in 1958, which later became the Kermit Extension of Odessa College's Vocational Nursing Program around 1979. (Both, courtesy of Kenneth Edwards.)

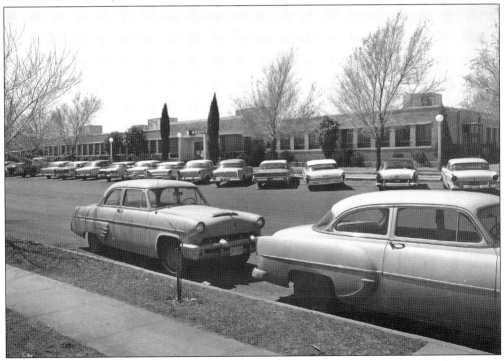

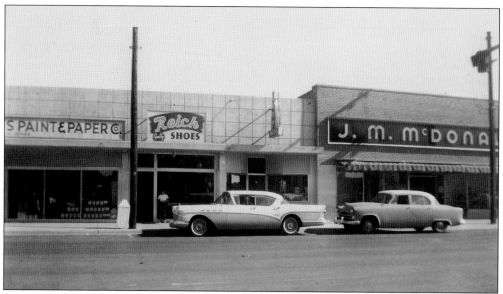

The picture above is of George and Betty Reich's shoe store. They opened Reich Shoes in 1957, and it was located on Austin Street. Out of the $200 they had in their savings account, the Reichs used $100 to open their store. They bought all of the fixtures and stock on credit, while the $100 paid for their first month's rent. Through hard work, they managed to make their business a success, and they ran it for 37 years, selling every last pair of shoes in their retirement sale in 1992. Betty Reich sold the last pair of 7 1/2 AAA for $1. The picture below shows George Reich working in his store; he passed away in 2010. (Both, courtesy of Betty Reich.)

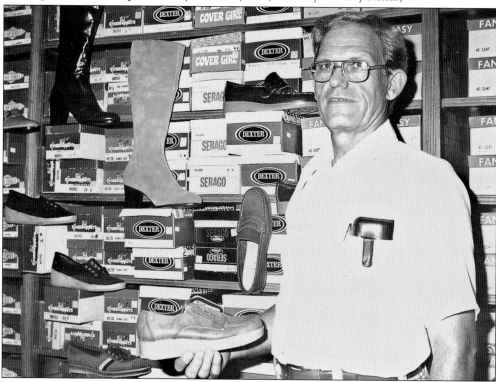

Lions Club member Tommy Thompson (right) is busy trying to sell raffle tickets to Charles Brinkley (left). Brinkley, reverend of the Community Church for 16 years, also wrote a sports column in the *Winkler County Newspaper* as ghostwriter "Amos Fuddle;" later, other Kermit writers continued the tradition. Thompson was a teacher, coach, principal, and later a superintendent for Kermit Independent School District (ISD). (Courtesy of Kenneth Edwards.)

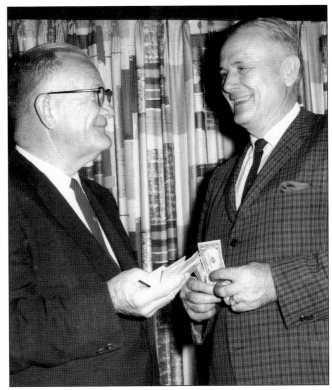

G.L. (Jerry) McGuire is seen here giving a speech to Kermit's Rotary Club. The Rotary Club is a service organization uniting business owners and other professionals and was organized in Kermit in 1960. McGuire was a band director, teacher, principal, and business owner. Jerry partnered with Raybon Lam in the Lam Motor Company, which he later bought and changed to McGuire Motors Chrysler, Plymouth, and Dodge. (Courtesy of Kenneth Edwards.)

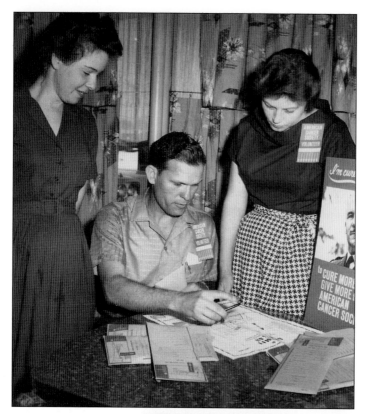

George Reich, Louise Hudson (right), and an unidentified female (left) are seen volunteering for the American Cancer Society in the late 1950s. Before the innovation of walks for charity, the volunteers would have to go door to door collecting donations. The envelopes on the table are for each volunteer. Reich looks at a map of Kermit to send volunteers to new areas. (Courtesy of Kenneth Edwards.)

From left to right, Kermit Chamber of Commerce members Calvin Wesch, George Reich, and unidentified pose for a photograph. The Lions Club originally filled in for an absent chamber of commerce, but one was created in 1946 by 30 citizens. They support community improvement and business progress in Kermit. George Reich served as the president in 1960. (Courtesy of Betty Reich.)

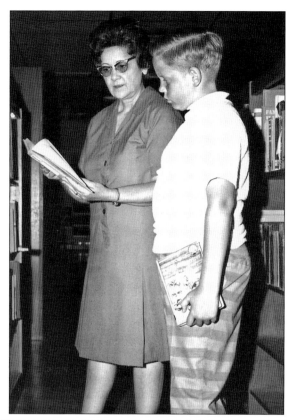

Rose Legrande helps Jay Cooper pick out a library book during Library Week in 1961. The Winkler County Library had a very successful summer reading program for students. The library was built in 1948 and cost $100,000. Rose Legrande became the head librarian in 1954 and served as such until her passing in 1972. The library continued to grow and built an addition in 1965. The library carries around 60,000 volumes of books, seven racks of fiction and nonfiction, and provides computers and even an area for the chess club. The picture below shows Rose Legrande with Ben Cowling in 1968. (Both, courtesy of Kenneth Edwards.)

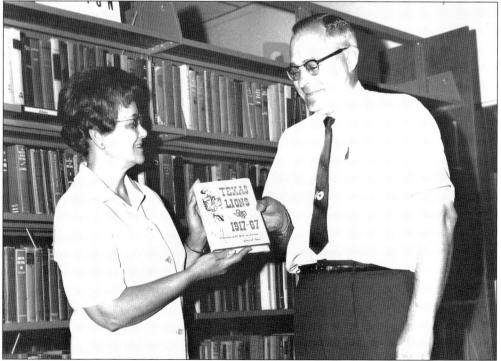

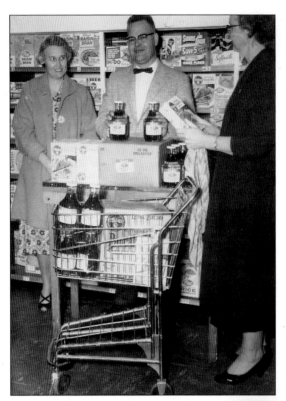

Lions Club members are shown here busily getting supplies for a pancake breakfast. From left to right are Sue Traueu, Carl Lawson, and an unidentified volunteer. The Kermit Downtown Lions Club used to have an annual pancake supper to raise money for their volunteer projects. The volunteers are shopping at one of Kermit's many grocery stores, such as the Serv-All, Spruills, the Piggly Wiggly, or Bells No. 1 or 2. (Courtesy of Betty Edwards.)

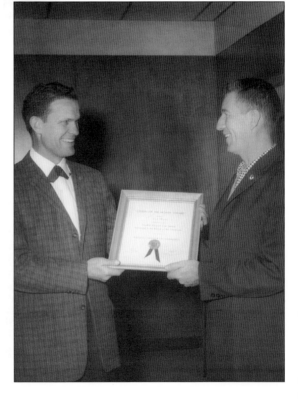

George Reich (left) presents an award to Frank Wharton (right) in 1960. George Reich was the chamber of commerce president in 1960, and Frank Wharton was chosen to receive the Citizen of the Month award. Frank Wharton was the organist for the Kermit Methodist Church, and he also helped with the Kermit High School music department. He passed away in 1975. (Courtesy of Betty Reich.)

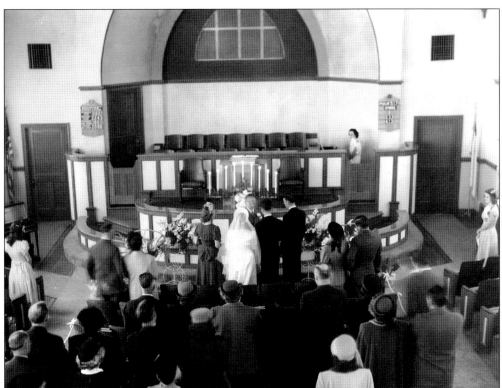

Here is a photograph of a wedding held at the Community Church in the early 1950s. The picture, taken from the balcony, details the inside of the Community Church. Smaller weddings were common for this period, with traditional seating of the wife's family on the right side and the groom's family on the left. In this wedding, there are no bridesmaids and groomsmen, only a maid of honor and a best man, which was traditional for the time. (Courtesy of Kenneth Edwards.)

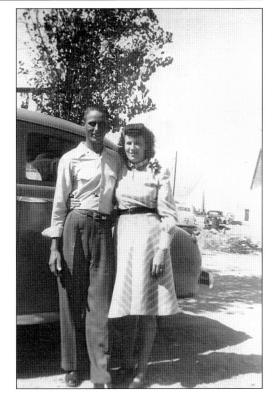

This picture of Johnnie and Lorene Abbott was taken the day after they were married in Kermit in 1947. Johnnie laid pipeline, and Lorene was the daughter of an oil field worker. They had a typical wedding for this period. First, they had to get their marriage license, and then after the three-day waiting period passed, they were married by the justice of the peace. (Courtesy of Kenneth Edwards.)

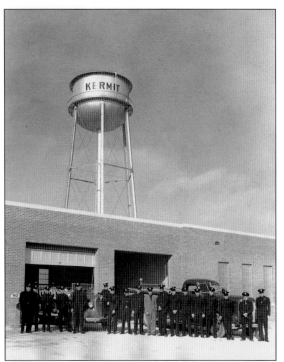

The Kermit Volunteer Fire Department was begun in 1937. The neighboring towns of Wink and Monahans already had volunteer fire departments. Kermit lacked even basic fire hydrants set up in case of a fire. Deficiency of an established fire department and any kind of fire hydrants became a serious problem in 1937 when a huge fire started in the Texan theater, burning down five buildings on Austin Street. Soon after incorporation in 1938, Kermit ordered a fire truck and installed fire hydrants. Kermit's volunteer fire department is still a very important part of life in Kermit. The department sponsors children's athletic teams, and its members volunteer to coach. They help with parades, town events, and even the Fourth of July fireworks show. They are essential for containing grass fires, pipeline explosions, and common building fires. (Both, courtesy of Kenneth Edwards.)

Constructed in 1947, the building above was originally constructed for the American Legion. In 1950, the county purchased the building to be used as the Winkler County Community Center. The community center has undergone a few renovations, but it is still the same building in the same spot. The community center is used for wedding receptions, banquets, community events, proms, and other occasions. From left to right, the 1947 picture at right shows Carolyn Perry, Ann Huda, and Mary Huda in front of the building's construction site. (Both, courtesy of Kenneth Edwards.)

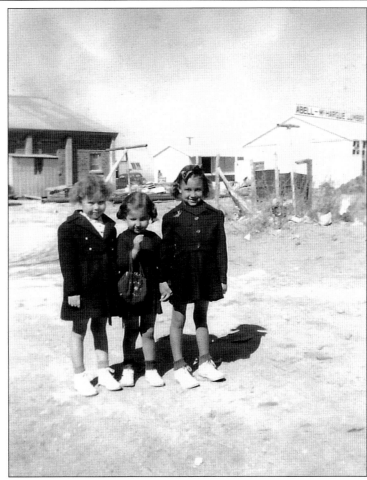

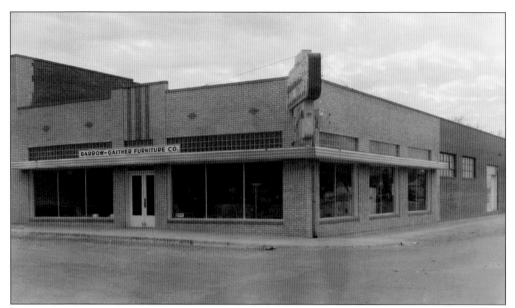

Barrow-Gaither Furniture Company was located across the street from the courthouse. Originally Marshall's Furniture, Barrow-Gaither acquired the business in 1947, and it later became Bud's TV, owned by Bud Eubank. After Marshall's sold, a manager of Marshall's, Nelson A. (Bud) Dyer, purchased Huckabee Used Furniture, which became Dyer Furniture Store. Furniture stores were flourishing in Kermit due to the oil boom and increased number of new residents. (Courtesy of Kenneth Edwards.)

Another oil boom in the 1940s created a housing problem. Real estate prices doubled, and houses were scarce, so J.B. Walton, a prominent rancher, built a Walton addition to the city of Kermit. The Boy Scout Hut, shown above, is located in the southern part of the addition. Helen Winborn Walton could not forget the girls, so she donated money for a Girl Scout Hut. (Courtesy of Kenneth Edwards.)

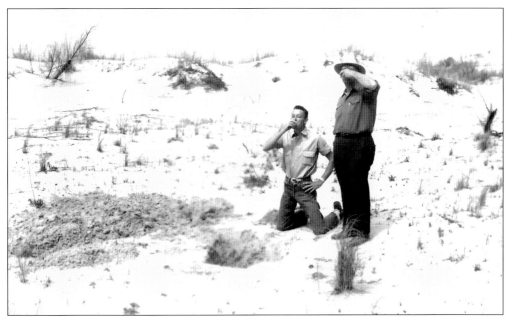

Two men are in the sand hills demonstrating how easy it is to find water. The climate in Kermit is as it is in any desert; smoldering hot during the day and cold during the night. Most surface water is evaporated during the day, but the shallow water table allows for easy access to water, which is one reason why early ranchers and farmers could survive without irrigation. (Courtesy of Kenneth Edwards.)

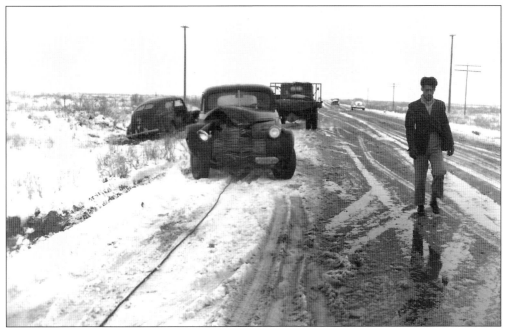

Not known for precipitation, every now and then Kermit does get a snowstorm. The snow-covered roads shown above caused this car to crash in the early 1940s. Kermit averages only about three inches of snow per year, so these snow days are usually a welcome change. (Courtesy of Kenneth Edwards.)

The Kermit Independent School District Administration building is located directly across the street from the Walton football field. The land for the football field was donated by J.B. Walton, as its name suggests. The administration building was erected in 1959, the same year as Purple Sage Elementary. The superintendent, assistant superintendent, and business staff are housed in the administration building. (Courtesy of Kenneth Edwards.)

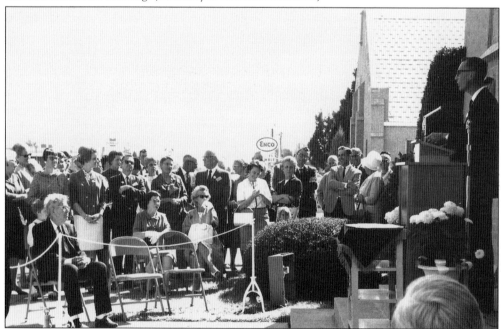

The celebration above was held in 1966 to grant a Texas Historical Marker to the Community Church. The Winkler County Historical Commission, under the guidance of Ray C. Kayser, researched and acquired all of the historical markers in the county. A memorial dedicated to this historian is located in Pioneer Park. (Courtesy of Kenneth Edwards.)

Kenneth Edwards and Betty Edwards are awarded Outstanding Jaycee and Outstanding Jaycee Wife in 1971. "Jaycee" stands for the Junior Chamber of Commerce. The Junior Chamber of Commerce was for younger men age 36 and under; women at that time were not a part of the Jaycees. The outstanding wife award was designated to a Jaycee's wife who volunteered to help the organization. (Courtesy of Kenneth Edwards.)

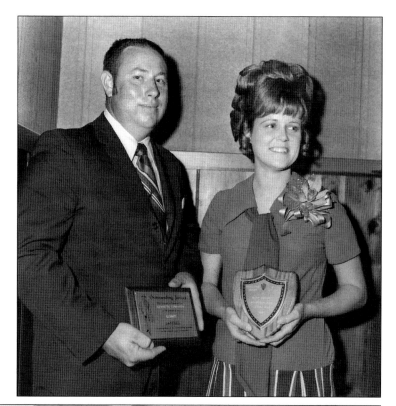

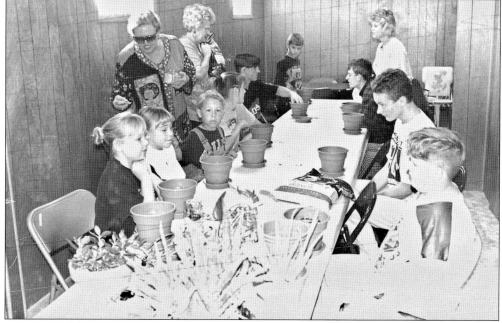

A meeting of the Kermit Junior Garden Club in the 1990s was held at the Free Will Baptist Church. Kermit Junior Garden Club was sponsored by the Kermit Garden Club. Standing from left to right, Kermit Garden Club members Pat Wight, Georgie Roberts, and Betty Edwards teach the Junior Garden Club how to plant flowers and the value of gardening. (Courtesy of Betty Edwards.)

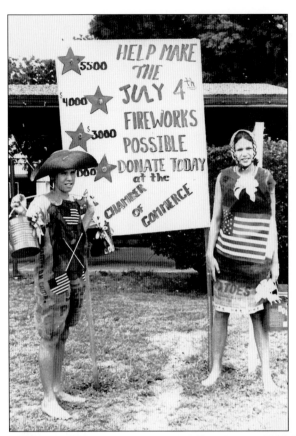

The Kermit Chamber of Commerce hosts an annual Fourth of July Celebration at the Winkler County Park. Tyler Williams and Lura Hayes (shown at left) are dressed in potato sacks in order to raise money for the Fourth of July fireworks show, paid for by the chamber. Fourth of July festivities include concession stands, dunking booths, merchandise booths, and more (sponsored by local businesses and churches), as well as free games such as sack races, a water-balloon toss, egg toss, and many others. A horseshoe tournament and an ultimate water-balloon fight are also a part of the festivities. Finally, the day culminates with the chamber-provided nighttime fireworks show. (Both, courtesy of Kaysie Sabella.)

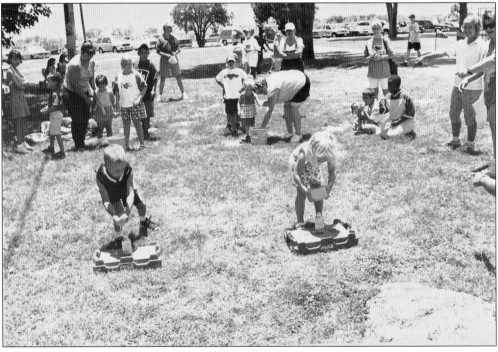

This picture, taken in the late 1990s, shows children visiting Santa Claus at the fire station. The volunteer firefighters host an annual Christmas party for their children and grandchildren. Santa listens to Christmas wishes, and gift bags of candy are presented to the children. (Courtesy of Kenneth Edwards.)

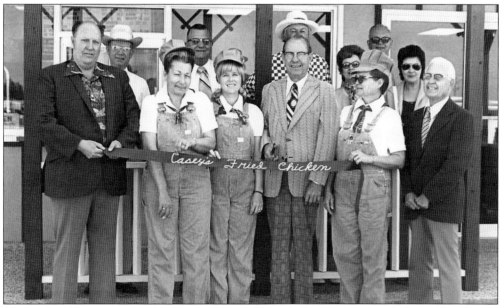

Here is the ribbon cutting at the grand opening of Casey's Fried Chicken in the late 1970s. Kermit mayor Jerry McGuire is cutting the ribbon, while the owner, Casey Pritchard (far left), holds one end of the ribbon. This ribbon cutting is one of the many that Mayor McGuire attended in his 26 years of service as Kermit's mayor. (Courtesy of Kenneth Edwards.)

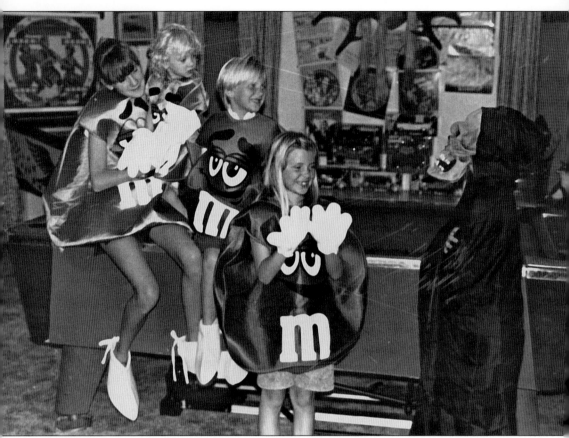

Seen here from left to right getting ready for the 1999 spook parade are Kaysie Williams, Aryn Edwards, Haleigh Edwards, Megan Edwards, and Tyler Williams, grandchildren of Kenneth and Betty Edwards, who snapped this photograph. The spook parade is a tradition in Kermit; merchants offer candy to a parade of dressed-up trick-or-treaters as they walk from business to business. The town's banks have even been known to give out quarters instead of candy. Kenneth and Betty's granddaughters are dressed as M&Ms, while their grandson Tyler is dressed as the Grim Reaper. (Courtesy of Betty Edwards.)

This picture of the Medallion Home was taken in 2010, which is a tribute to its over 100 years in existence. The Medallion Home, as it is known today, was built outside of town in 1907 by W.H. Seastrunk and moved to Kermit in 1910. W.E. Baird Sr. bought the house in the 1920s, and it continued in their family until 1967, when the house and land was sold to Kermit ISD. The City of Kermit purchased the house for a dollar and relocated it to Pioneer Park in 1968, where it remains. After restoration projects were finished, the house was fitted with furnishings and décor donated by Kermit residents, including the Baird family. In 1974, the Medallion Home was opened to visitors as a house museum. (Both, courtesy of Betty Edwards.)

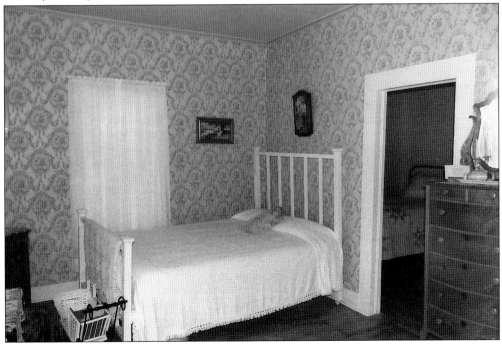

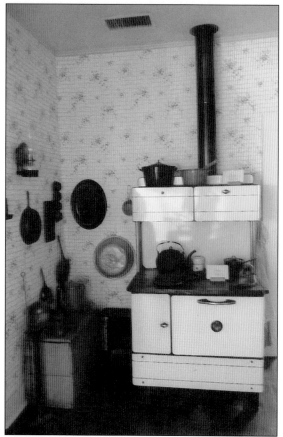

The Hostesses of the Medallion Home look after the house and open it for visitation every Sunday, excluding holidays. The volunteer organization, also known as the "Medallion Home Hostesses," was organized in 1974. They give tours and explain the different furnishings like the wood-burning cookstove (shown at left) donated by Dr. Cecil Robinson and the New Home treadle sewing machine (shown below). Other items of the period shown in the house include bookcases used in the original 1910 courthouse, a coffee grinder, cookbooks donated by Ray and Margaret Shipp Kayser, a potbellied stove donated by Mrs. Tom Linebery, and even a 1937 Spruill's Grocery advertisement, which was found underneath the house when it was relocated. (Both, courtesy of Betty Edwards.)

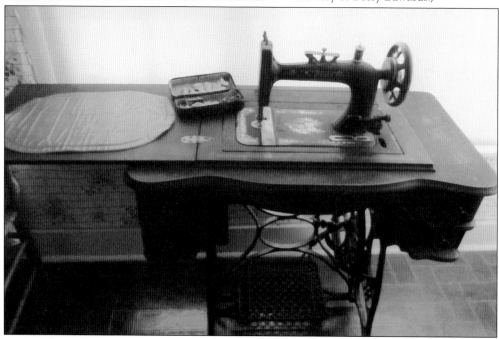

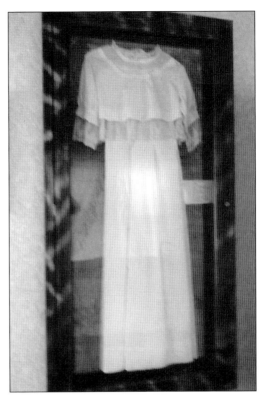

Not only period furnishings adorn the house museum; some of the displayed items are also clothes worn during the period. It is these items that make the visitor realize that this museum was really a family's home. Aprons are hanging in the kitchen, shoes are displayed, and even an actual wedding dress is preserved in this museum. The wedding dress (shown at right) was owned and worn by Kate Lovett during her wedding to W.E. (Ern) Baird on August 24, 1915. W.E. (Ed) Baird Sr. was once the owner of this home, and his family was the only family that lived in town in 1924. Kate and Ern's daughter Louise was the only student in Kermit ISD in the fall of 1924. (Both, courtesy of Betty Edwards.)

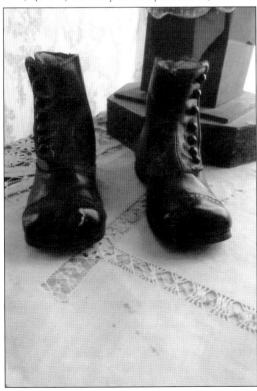

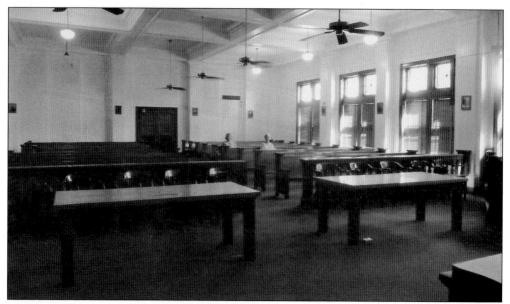

Here is the District Courtroom, located in the 1929 Winkler County Courthouse. The first county judge to serve in the 1929 courthouse was S.M. Halley; the district judge to serve this courtroom was Charles Gibbs. Other officials at this time were county commissioners J.B. Walton for Precinct One, Homer A. Pace for Precinct Two, Seth Campbell for Precinct Three, and G.C. Dawson for Precinct 4; W.E. Baird Jr., first county and district clerk; Hill D. Hudson, county attorney; and Birge Holt, district attorney. The courtroom, along with the rest of the courthouse, looks almost the same today as it did in 1929. It still has its original 1929 furniture with a few new additions. The staff at the courthouse has been vigilant in preserving everything down to the furnishings in the courthouse. (Both, courtesy of Kaysie Sabella.)

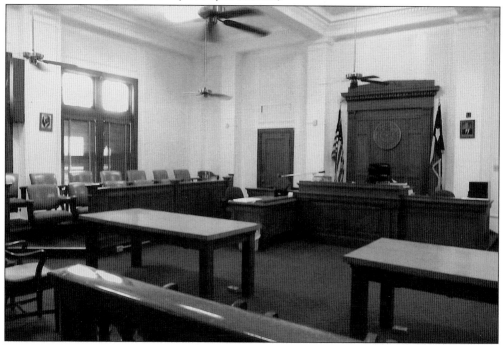

Jo Ann Lujan demonstrates how the 1929 elevator works. It is a bit more detailed than modern elevators. The gate has to be closed, and a lever—instead of buttons—controls which way the elevator travels. Another difference is the brass foot pedal that serves as the elevator's brake. The elevator was built and installed by the Otis Elevator Company, the same company whose elevators are in the Eiffel Tower. It is probably not the oldest elevator in a Texas courthouse, but it might possibly be the oldest *operating* elevator in any Texas courthouse, the elevator is still a part of everyday business at the Winkler County Courthouse, helping staff traverse the four-story building. (Both, courtesy of Kaysie Sabella.)

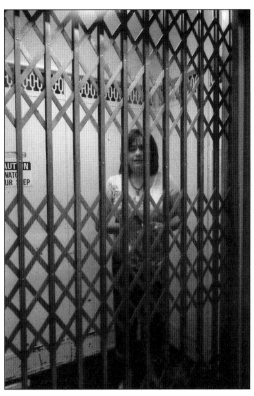

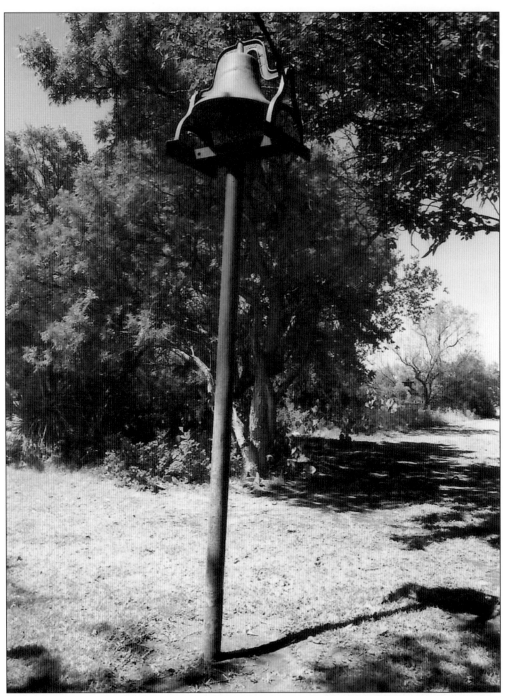

Kermit's original school bell currently is located at Pioneer Park. This bell was brought by wagon to Kermit in 1910 and placed on the roof of the first school in Kermit. Unfortunately, the bell fell from the roof and cracked; however, it was saved and remained on the campus. When a new school was built in 1929, the bell was given an honorary position. In 1937, Kermit students designated the bell as a victory bell. Finally, the bell was moved to Pioneer Park in 1975 as a piece of history from the Kermit Independent School District. (Courtesy of Betty Edwards.)

Pictured above is the new Winkler County Pool, located in Kermit. The new pool is located east of the original pool, closer to the Recreational Center, and is set to open in the summer of 2011. Although the new pool is much smaller than the original, plans to increase the size at a later date are in place. (Courtesy of Kaysie Sabella.)

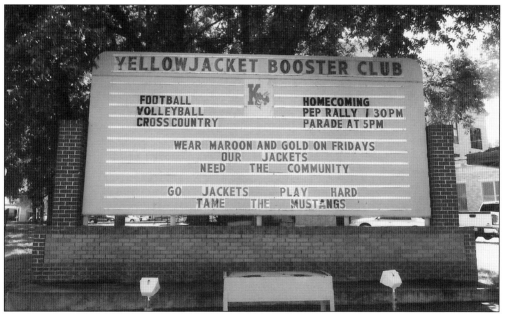

This picture shows the announcement board. The board is located on the northeast corner of the courthouse between Austin Street and Poplar Street. The Kermit Yellow Jacket Booster Club raised the funds for this announcement board, and it continues to inform the community of upcoming events. The board is intended to relay important information as well as promote team spirit and school support. (Courtesy of Kaysie Sabella.)

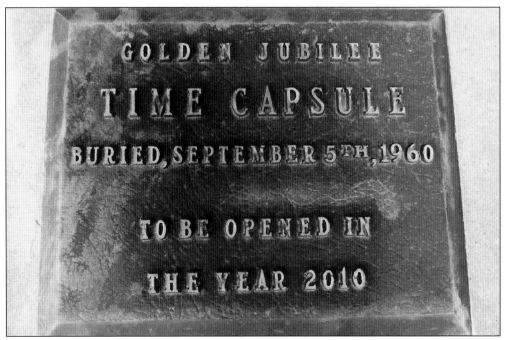

The marker shown above was placed on the courtyard to the left of the double doors on the south entrance to the courthouse. The marker was left to indicate where the 1960 time capsule was buried and to remind the public of when it would be unearthed in 2010. The 1960 capsule was buried as part of the semicentennial Golden Jubilee celebration commemorating the 50th birthday of Winkler County. On September 25, 2010, as part of the Kermit Celebration Days, the 1960 time capsule was exhumed. Luckily, its contents were wonderfully preserved; they were put on display inside the courthouse for public viewing. (Both, courtesy of Kaysie Sabella.)

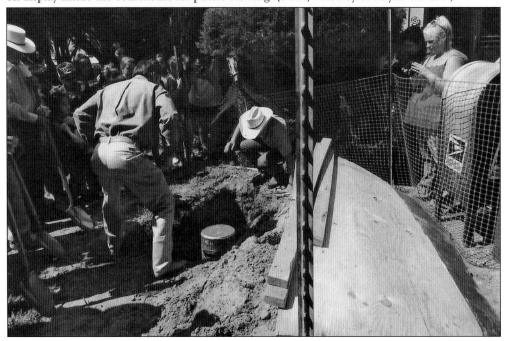

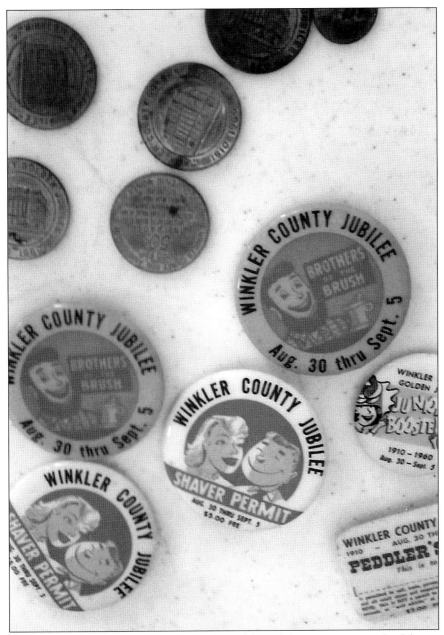

The original time capsule was buried during the Golden Jubilee semicentennial celebration that ran from August 30 through September 5. The celebration included fireworks, an old-fashioned barbeque, a queen's coronation ball, an old fiddler's contest, a ladies' day (which included a fashion show with fashion through the decades), and finally the burying of the time capsule. In 2010, the time capsule was unearthed and people got a glimpse of the contents. Mayor Ted Westmoreland initially removed books advertising the 1960 Golden Jubilee, and then the rest of the contents were revealed. Letters like one from the 1960 sheriff addressed to the 2010 sheriff, letters to relatives, and even letters from business owners to the chamber of commerce were included in the time capsule. Random items like semicentennial buttons and coins (shown above), business cards, pictures, and newspapers were also discovered. (Courtesy of Kaysie Sabella.)

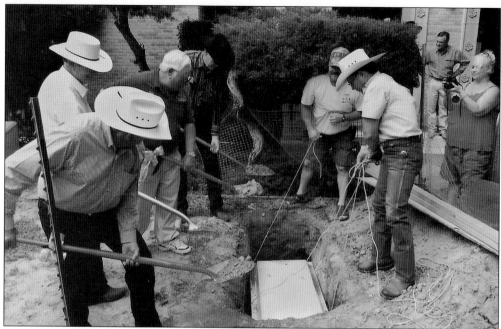

The 2010 time capsule was buried in the same spot as the 1960 time capsule and is scheduled to be opened in the year 2060. Members of the community were allowed to place items in the time capsule for future discovery. Seen here from left to right are county commissioner Randy Neal, Dean Crocker, Bill Waddell, Kenneth Edwards, Mayor Ted Westmoreland, and Bill Mitchell as they help bury the new time capsule. (Courtesy of Kaysie Sabella.)

The members of the 2010 Kermit Garden Club are pictured here on November 11, 2010, during the Centennial Veterans Day celebration. From left to right are Veta Reese, Betty Edwards, Pat Wight, Fred Dunlap, Betty Hayes, Kermit Garden Club president Dorothy Parker, Texas Garden Clubs president Jackie Simmers, and Lyda Smith. The cake, which is a replica of the Kermit courthouse, was made by Rodney Hayes, owner of Mary's Flowers. (Courtesy of Betty Edwards.)

Veteran Kenneth Edwards (left) is pictured with Congressman Mike Conaway (right) on November 11, 2010. Congressman Conaway and State Rep. Tryon Lewis were present during the Centennial Veterans Day observance, which included the dedication of two memorials: the Blue Star Memorial donated by the Kermit Garden Club and the Veteran's Memorial donated by the American Legion Auxiliary. (Courtesy of Kaysie Sabella.)

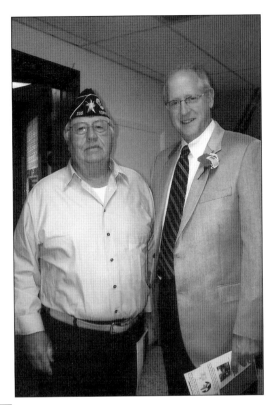

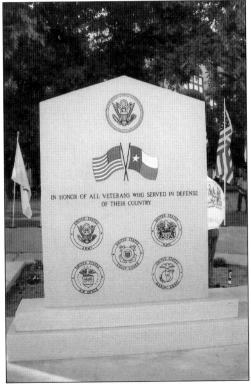

The American Legion Auxiliary raised funds for this veteran's memorial located on the southeast corner of the courthouse lawn, now known as the Winkler County Courthouse Memorial Garden. The memorial was unveiled during the Centennial Veteran's Day observance on November 11, 2010. The memorial includes the names of lost soldiers from Winkler County and the wars that they dedicated their lives to fight. (Courtesy of Kaysie Sabella.)

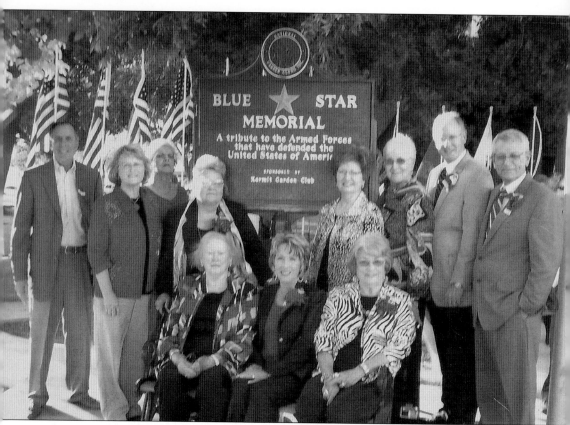

Blue Star Memorial was created by the National Garden Clubs as a way to honor servicemen and servicewomen. The Kermit Garden Club worked for two years holding plant sale fundraisers to pay for the memorial. Finally, on November 11, 2010, their goal was realized with the dedication of the Blue Star Memorial. Seen here from left to right are (seated) Pat Wight, Winkler County judge Bonnie Leck, and Kermit Garden Club president Dorothy Parker; (standing) District Judge Martin B. Muncy, Betty Edwards, Betty Hayes, Texas Garden Clubs president Jackie Simmers, Lyda Smith, Veta Reese, Congressman Mike Conaway, and State Rep. Tryon Lewis. (Courtesy of Kaysie Sabella.)

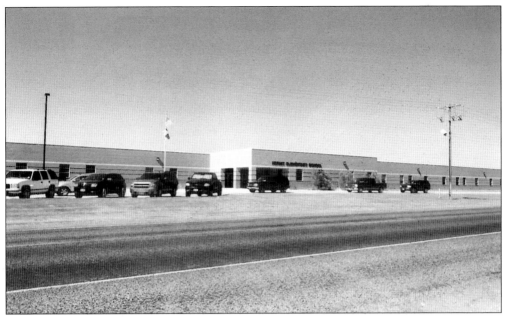

Kermit Elementary School was just recently completed and opened in 2009. The new elementary school actually replaces two elementary schools, East Primary and Purple Sage. East Primary, completed in 1949, educated pre-K through second grade, while Purple Sage Elementary, completed in 1959, taught third grade through fifth grade. The new elementary school combines pre-K through fifth grade in the same school. (Courtesy of Kaysie Sabella.)

Currently under construction is a new high school. The current Kermit High School was finished in 1951 and was located to the left of East Primary Elementary. The new high school is located at the site previously held by East Primary across the street from the junior high. While completely new, a few pieces from the 1951 high school will be preserved for the new school. (Courtesy of Kaysie Sabella.)

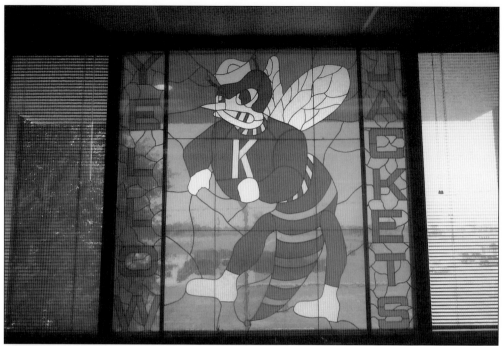

Of course, the trophies will be relocated to the new high school, along with books and computers, but what else will be preserved? Even though there is a new high school under construction, the auditorium and the band hall from the 1951 high school will be preserved. Another item to be relocated will be the stained-glass Yellow Jacket (shown above) that adorns the front entrance of the 1951 high school. The picture shows the *Yellow Jacket*, created by a former teacher, Wanda Alexander, from inside the library. Many elements such as the *Yellow Jacket* sculpture at left will be easily relocated, while certain pieces like the Yellow Jacket tiles in front of the auditorium and gym entrance may not be able to be preserved. (Both, courtesy of Kaysie Sabella.)

Judge Mary Francis Clark was Winkler County's judge from 1979 to 1994. She was truly a leader in breaking down barriers. Judge Clark was not only the first female judge but also the first write-in candidate ever elected in Winkler County. Among other firsts, she was the first female member of both the Kermit Downtown Lions Club and the Kermit Rotary Club. (Courtesy of Vida Simpson.)

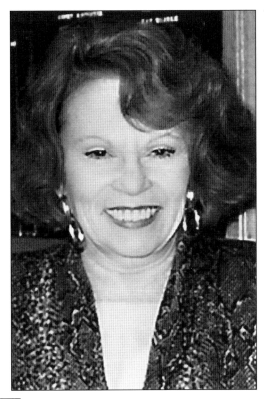

Judge Bonnie Leck is Winkler County's current judge. She was elected in 1994 and took office in 1995. Much like her predecessor, Judge Bonnie Leck has continued to be reelected to office. During Judge Leck's time in office, a new county hospital, two new schools in Kermit, and new county swimming pools in both Wink and Kermit have been built. The county also celebrated its centennial. (Courtesy of Vida Simpson.)

Construction of the East Primary Elementary School was completed in 1949. The new elementary school taught first and second grade. It was not until 1971 that kindergarten classes were added. East Primary was built on School Street before the 1951 high school or current junior high school had been constructed. In 1978, remodeling was completed on East Primary in order to conserve energy. Another addition in 1982 changed the auditorium into office space and a new addition included library office space, storage rooms, and an activity room that doubled as an auditorium and gymnasium. (Courtesy of Kenneth Edwards.)

Four

SCHOOL DAYS

Born in 1936 in Oklahoma, "Sonny" Don L. Perry was moved to Kermit by his family as another product of the migration to Kermit due to the increase of jobs in the oil and gas industry. This picture was taken at his home in Kermit in 1942 when Sonny was five years old; the box camera used to capture this picture cost $5. (Photograph by Lorene Perry Abbott; courtesy of Kenneth Edwards.)

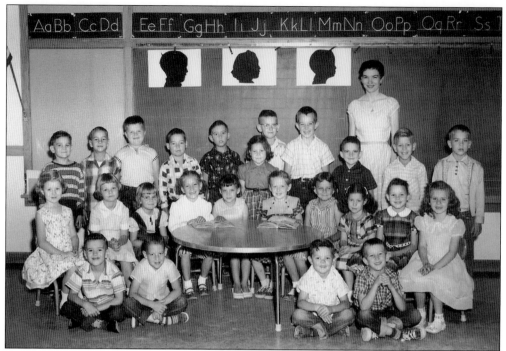

Dorothy Parker's first grade class poses for a class photograph (above) in 1956. The 1955–1956 school year was Parker's first year teaching, with a teacher's salary of $273 a month. A devoted teacher, she taught in Kermit her entire career and most of that was spent teaching first grade, although she also taught second grade the last few years of her 43-year career. The picture below is of Parker's 1966 class and their "Haircut Play." The names on each student are actually the names of the characters they played. (Both, courtesy of Dorothy Parker.)

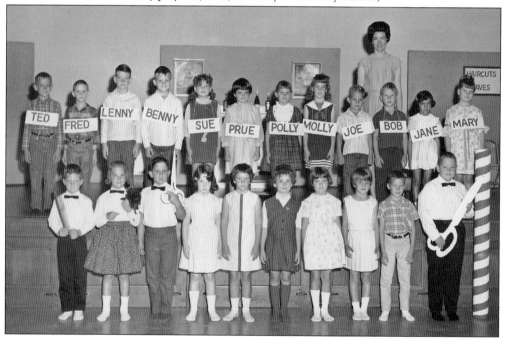

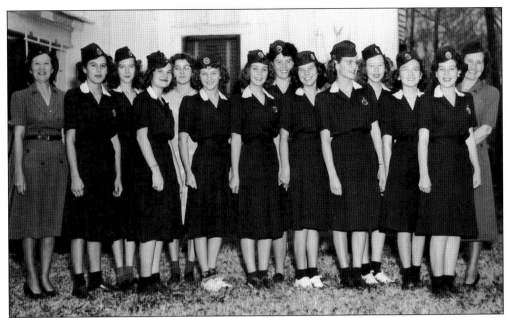

This picture is of Kermit's Tonkawa Senior Scout Troop of 1947. The Tonkawa organization had a scout troop in Kermit until 1984. Included in this picture are Mrs. Sam Montgomery (leader), Ann Charlton, Rita Jean Harwell, Janice Ledbetter, Mary Lou Adams, Alice Sue Mullinax, Greta De Shazo, Bonnie Jean Williams, Ann McGee, Pat Williams, Marjorie Barton, Barbara Shelley, Margaret Barton, and Mrs. A. C. Williams (leader). (Courtesy of Kenneth Edwards.)

Rainbows was a group of girls ages 14–16 who were on their way to earning their Eastern Star Degree. These were the sisters, daughters, and granddaughters of Master Masons. Being accepted into the Rainbows, Eastern Stars, or Masons was seen as a great and distinguished honor. The goal of the Mason organization and its many branches is to promote goodwill through charities. (Courtesy of Kenneth Edwards.)

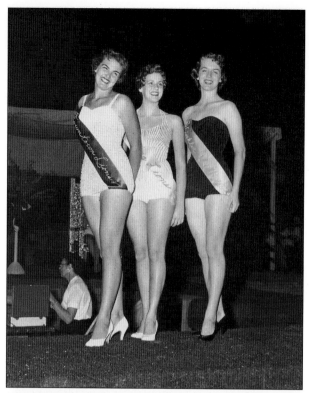

The Miss Kermit Pageant was held every Labor Day during the Kermit Labor Day Celebration. The girls were sponsored by local businesses and organizations such as the Kermit Lions Club and the *Winkler County News*. The winner of the Miss Kermit Pageant was then elevated to the Miss West Texas Pageant held in Odessa, Texas. While the Miss Kermit Pageant is no longer being held, the Miss West Texas pageant is still intact and is now known as the Miss Teen West Texas. These pictures were taken in the late 1950s. Three of the contestants of the 1957 pageant shown at left are, from left to right, Ariliss Froelich, Shirley Davis, and Ellen Stewart. The name of the winner (below) is not known. Patty Lafferty was crowned Miss Kermit in 1955. (Both, courtesy of Kenneth Edwards.)

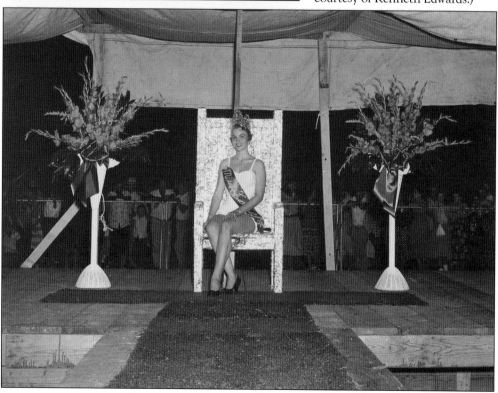

C.V. and Evelyn Keedle with their daughter Virginia are pictured standing in front of the Kermit Junior High School in the late 1940s. The Kermit intermediate school opened in the fall of 1947 placing grades six–eight in Kermit's first junior high. Originally, all students went to the same school, but as the population increased, the first high school was built in 1936. It later became the junior high. (Courtesy of Kenneth Edwards.)

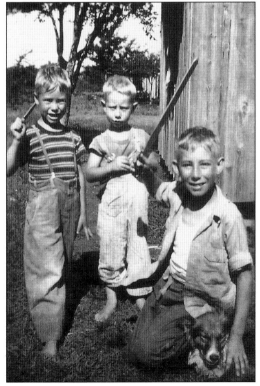

Taking a break, from left to right, Don "Sunny" Perry, Kenneth Edwards, James Edwards, and their dog, Spot, pose for a picture. The boys temporarily halted their stick-sword fight but quickly resumed the battle after the picture was taken. Even though the town was booming in the 1940s, children still had to keep themselves entertained without the aid of television or video games. (Courtesy of Kenneth Edwards.)

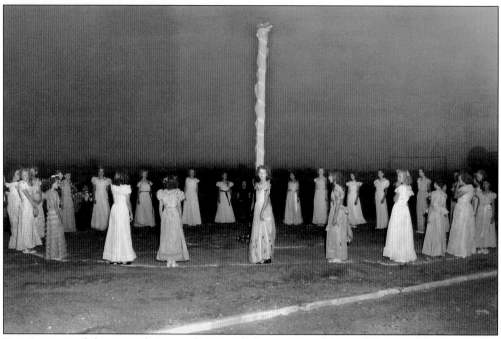

Dancing around the maypole is a tradition with deep roots in history. May 1, or May Day as it is traditionally called, is typically celebrated to welcome spring. Mayfest, held in Kermit, included a maypole dance at the football field while the band played and the choir sang. A Mayfest queen would also be elected. The above picture was taken at a Mayfest in the 1950s. (Courtesy of Kenneth Edwards.)

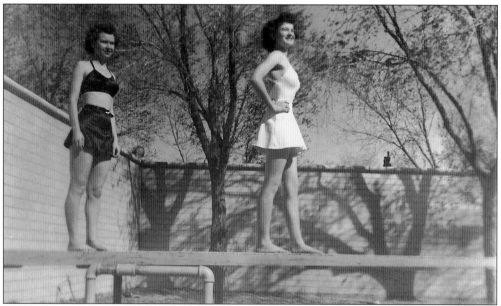

Pin Holland (left) waits while Jonelle Nesterman gets ready to jump off the diving board. Until 1954, the only swimming pool in town was located at Kermit High School. Built in 1941 as an addition to the 1936 high school, this swimming pool was a mainstay of summer entertainment in Kermit. (Courtesy of Kenneth Edwards.)

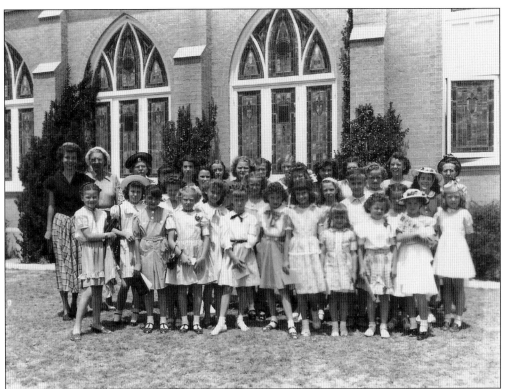

Sunday school girls at the Community Church dress in their Sunday best for Easter in the 1950s (shown above). Easter in Kermit is celebrated with nice clothes and Easter egg hunts. While individual families may have their own egg hunts, churches in the area, along with the county, also host Easter egg hunts. An annual Easter egg hunt is held on the courthouse lawn for the community, with a few prize eggs included in the hunt. Pictured at right, from left to right, Carolyn Perry, Don "Sunny" Perry, Mary Huda, and Kenneth Edwards get ready to hunt for Easter eggs in the early 1940s. (Both, courtesy of Kenneth Edwards.)

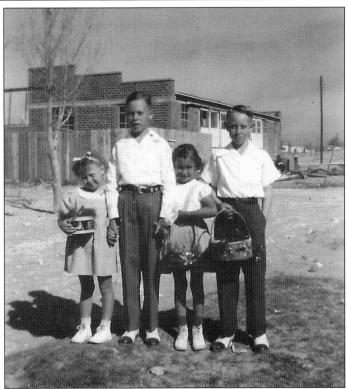

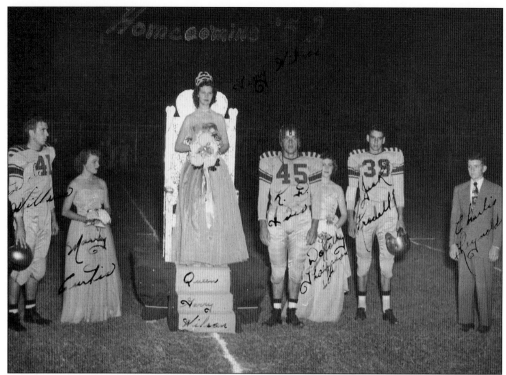

This photograph shows Kermit High School's 1952 Homecoming court. From left to right are Dole Williams, escort for runner-up Mary Curtis; Mary Curtis; Homecoming queen Gerry Wilson and her escort, K.D. Ives; runner-up Dorothy Thompson and her escort, Jack Krodell; and Charlie Reynolds, who drove the nominees onto the field in a convertible. (Courtesy of Fred Dunlap.)

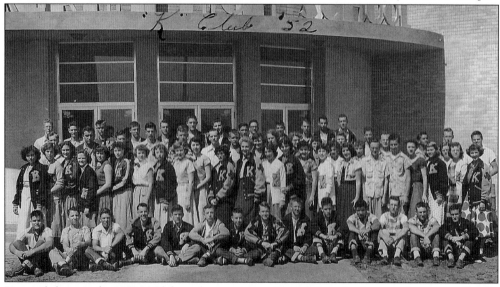

Pictured above is the 1952 K Club, an honor society for students who kept an A average. Grades 10 through 12 could be members, but they had to go through an initiation—which largely consisted of wearing silly clothes. The K Club was comparable to the current National Honor Society. (Courtesy of Fred Dunlap.)

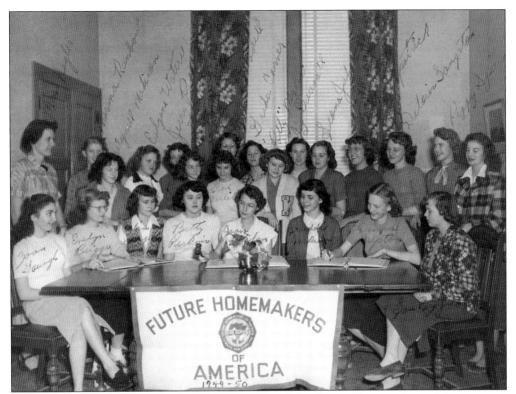

The 1949–1950 senior high officers and members of the Future Homemakers of America are shown above. The Future Homemakers of America is similar to home economics. They were taught etiquette, sewing, childcare, and cooking. It was not solely designated for girls; boys could also be in the Future Homemakers of America. (Courtesy of Fred Dunlap.)

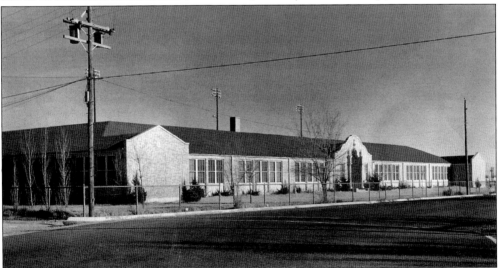

The Kermit Intermediate School, pictured above, was built in 1947 because of a sudden increase in the population due to an oil boom. The building, which no longer stands, was located on South Mulberry Street close to the football stadium. Grades four and five were taught at this school. (Courtesy of Kenneth Edwards.)

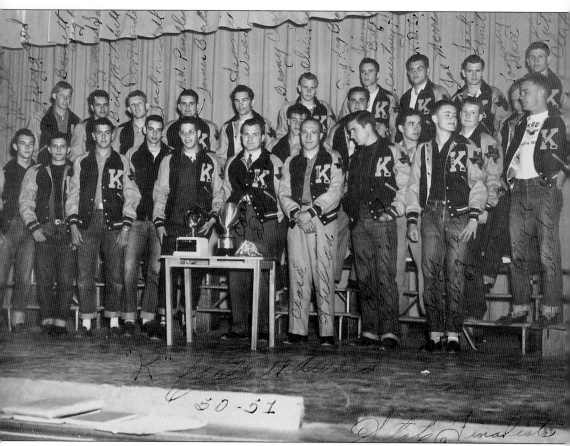

Members of the 1950–1951 Kermit High School varsity football team are shown above receiving their letterman awards. The first year that the new Kermit High School was opened the varsity football team won district and went all the way to state. Unfortunately, they were defeated there by Wharton 13-9, but it is still the only Kermit football team to be named state finalists. Seen here from left to right are (first row) Joey Marshall, Pay Haygood, Bill Mitchell, Jack Krodell, James Burkhart, coach Neal Dillman, assistant coach Bob Shelton, Dale Williams, and Wayne Culvahouse; (second row) Bennett Wight, Raymond Laird, Don Handlin, B.W. Pendleton, Sammy Wood, Benny Carr, Oliver Batchelor, Don Kay Brown, James "Jimmy" Bolf, Courtney Holt, K.D. Ives, Joes Morris, Jack Smith, Tommy Gore, and Keith Clark. Missing from the photograph are Ricky Spinks and Martin Beebe. (Courtesy of Fred Dunlap.)

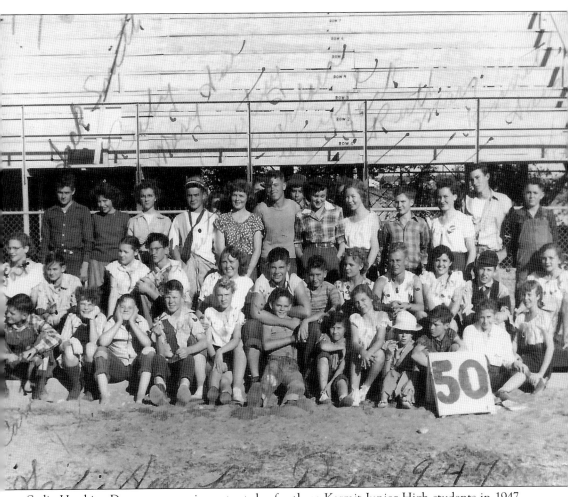

Sadie Hawkins Day was a very important day for these Kermit Junior High students in 1947. The girls would get especially excited because it was not proper etiquette for girls to ask boys out, except on Sadie Hawkins Day. (Courtesy of Fred Dunlap.)

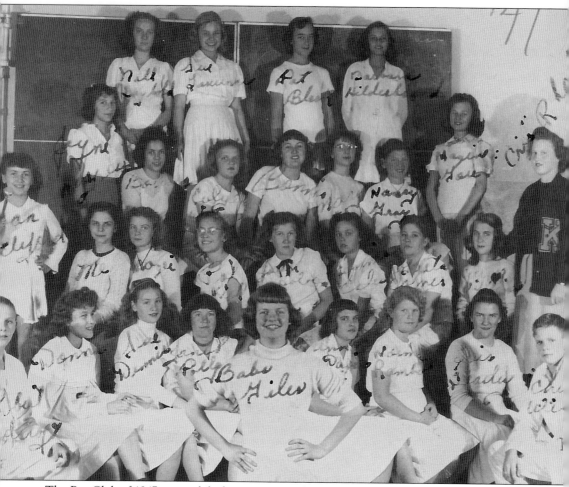

The Pep Club of 1947 was a club that anyone could join. They were present at all Kermit High School sporting events, cheering on the Kermit Yellow Jackets. They sat together and wore white shirts. Both boys and girls were members of this pep squad. Cris Rhodes, standing on the right, was the sponsor. (Courtesy of Fred Dunlap.)

Gerry Wilson was the drum major for the K Band, 1951–1952. She is shown above wearing the traditional drum major uniform. Gerry was a senior and is shown below leading the marching band at Walton Field in Kermit. The K Band had grown quite large by this time thanks to the efforts of band director G.T. Gilligan, who instituted a junior high and beginner's band. Gilligan arrived in 1944 to a band of 32, and by 1960, he had increased the band to 120 in high school, 75 in junior high, and 60 in beginner's band. The K Band was very successful under the direction of G.T. Gilligan, which is why the band hall attached to the 1951 high school is named after him. (Both, courtesy of Fred Dunlap.)

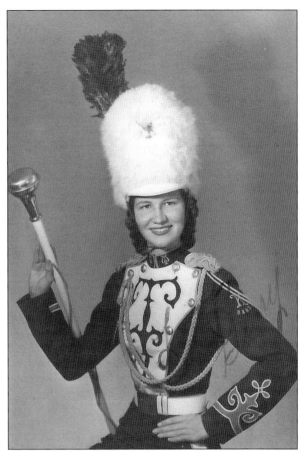

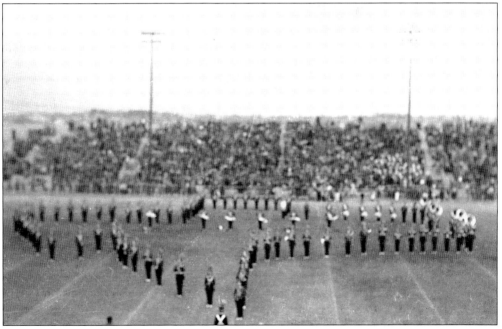

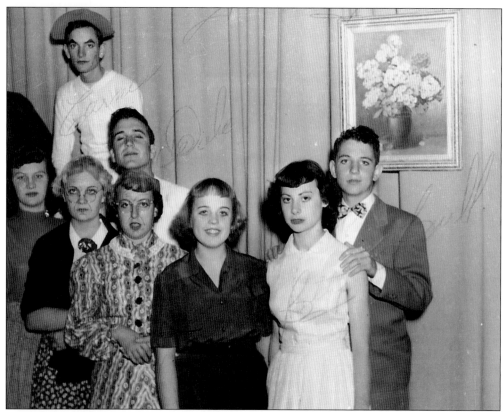

This photograph shows the cast of the play *The Inner Willy*, a three-act comedy, put on by the junior class on December 5, 1950. The cast held three performances at the Kermit High School auditorium and admission cost 60¢ per ticket. Class plays are almost nonexistent now that Kermit participates in the UIL one-act play competition. Anyone, freshman through senior, can try for a part in the one-act play. (Courtesy of Fred Dunlap.)

Freddie Jackson (left) and Patsy Riley (right) are all dressed up for Western Day in 1951. Throughout the school year, random days would be selected for fun themes, such as Western Day. The tradition has continued and evolved with time. More recently, a whole school week such as Homecoming Week will be targeted for special days like Pajama Day, Crazy Hat Day, and Spirit Day. (Courtesy of Fred Dunlap.)

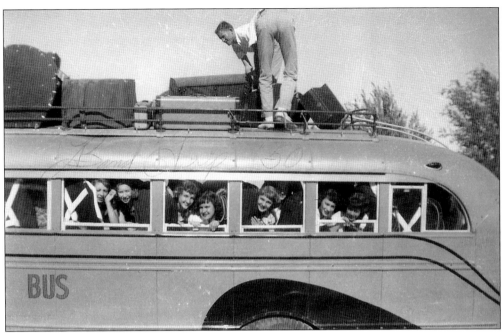

The band is shown here getting ready to travel to a football game in 1950. All of the larger instruments were placed on top of the bus. Kermit's first school bus was purchased in 1929. Current buses are not equipped to carry instruments, so band trucks are needed to transport those. (Courtesy of Fred Dunlap.)

Freddie Jackson sits on top of the Texas state marker located on the Texas-New Mexico border. Kermit is only located about eight miles south of New Mexico. The nearest town in New Mexico is Jal, which is in a different time zone, making it one hour behind Texas time. A trip to New Mexico is always fun for first-time drivers from Kermit. (Courtesy of Fred Dunlap.)

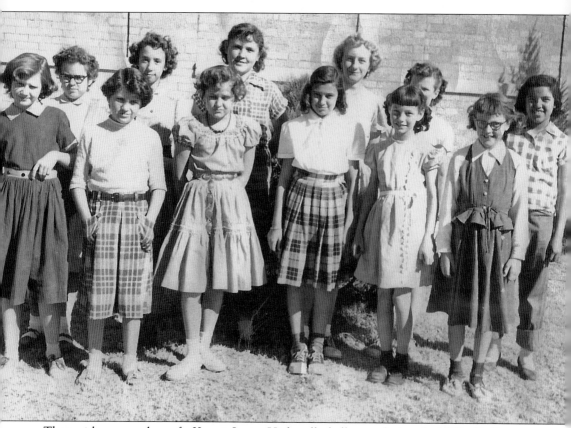

These girls are members of a Kermit Junior High volleyball team during the 1950s. Unlike most team photographs, these girls are not dressed in their uniforms, which was not uncommon in the 1950s. Although Kermit has won many titles, it has never won a title in volleyball. (Courtesy of Kenneth Edwards.)

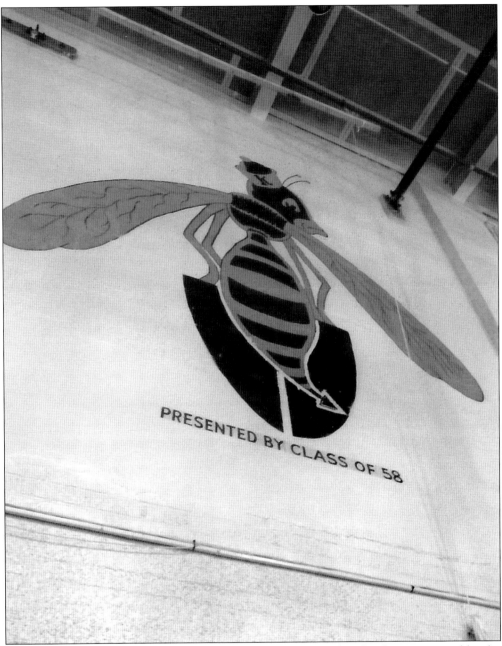

This yellow jacket painted in the gym of the 1951 Kermit High School was presented by the graduating class of 1958. The yellow jacket is located on the west wall of the gym, just above the first set of double doors, and has been preserved as a source of school pride. Kermit's mascot has been modified since 1958, given a tougher, more masculine and modern look, but he retains the school colors of maroon and gold. Unfortunately, a new high school is being built and this painting will probably be demolished along with the yellow jacket–embedded tiles and the rest of the school, excluding the auditorium and band hall. The 1958 yellow jacket is also accompanied on the gym walls by a painting of the school song, "Onward K.H.S," written by H.H. Copeland, Kermit's first band director. (Courtesy of Kaysie Sabella.)

Two boys compete in a boxing match in the mid-1960s as part of the Silver Gloves Boxing tournament sponsored by the Kermit Junior Chamber of Commerce, or Jaycees. Kermit had a boxing club called the Golden Gloves, and these boys were the future of that club. (Courtesy of Kenneth Edwards.)

Members of one of Kermit's little league softball teams, sponsored by McGuire Motors, are shown here receiving their trophies on award night in 1975. Girl's softball is growing increasingly popular in Kermit. The little league softball teams are sponsored by local businesses and coached by volunteers. They play at the only softball field in town, located north of the county park. (Courtesy of Betty Edwards.)

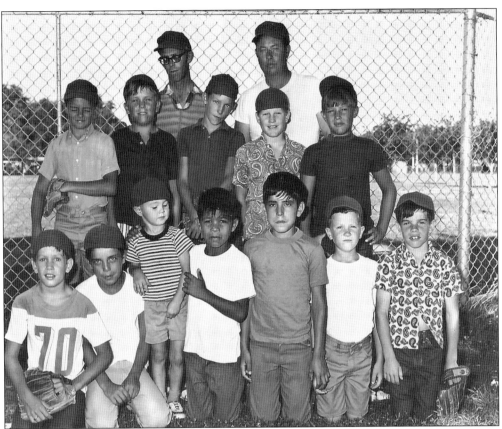

Shown above is a little league baseball team from the late 1960s. Kenneth Edwards, standing in the back to the right, was the volunteer coach. The creation of the two lighted baseball fields in 1954 at the county park really spurred summer baseball teams. Before matching hats and shirts were common, these boys only needed a volunteer coach and baseball gloves to play. (Courtesy of Kenneth Edwards.)

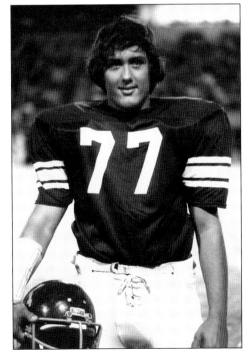

Cletus Thompson is pictured in his varsity football uniform in 1978. Kermit High School's 1978 varsity football team was not just district champions for division AA, but were also Texas State quarter-finalists. They were the first team since the 1950–1951 state-finalist team to qualify for the quarter-finalist game. Both of Cletus's sons, Todd and Taylor Thompson, followed in their dad's footsteps and played football for Kermit. (Courtesy of Virginia Thompson.)

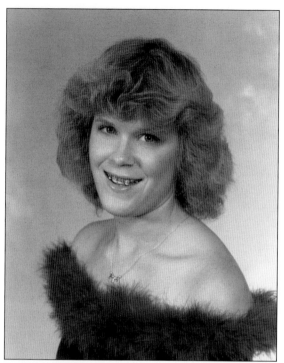

Shown at left is Judy Edwards's senior photograph taken for the 1982 yearbook. Judy is wearing a maroon top detailed with feathers, which became a tradition for the senior girls' pictures in the *Sandstorm* yearbook. The tradition was started by Phil Parks, a Kermit Junior High principal. Parks was also a photographer who took senior photographs for Kermit ISD for over 20 years. The tradition began in 1981 and lasted over 20 years before coming to end due to Parks's moving from Kermit. (Courtesy of Betty Edwards.)

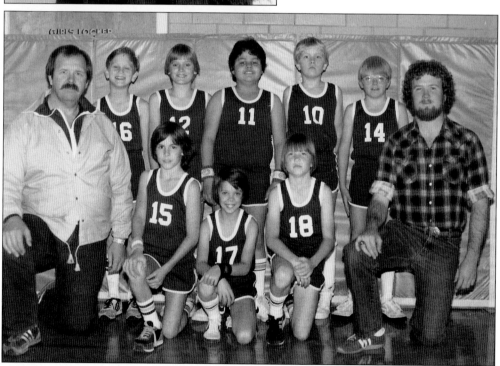

A 1980s Little Dribblers basketball team poses for a team photograph. Little Dribblers is a youth basketball league in Texas. The Kermit Little Dribblers league is designated for children in sixth grade and younger. Each team has between six and 10 players and has volunteer coaches. (Courtesy of Betty Edwards.)

The 1950–1951 Kermit High School was built out of a need for a larger school. The two-story brick building was located on School Street before East Primary and the current junior high were built. Unique details decorated the new school, such as the five-foot maroon and gold inlaid yellow jackets tiles located at the auditorium entrance and the gym entrance, shown below. An addition to the front of the school was completed in 1982. A stained-glass yellow jacket was placed in the windows in front of the library over the main entrance to the school. (Both, courtesy of Kenneth Edwards.)

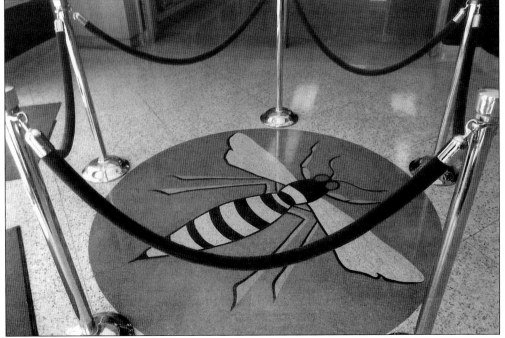

Amy Bell, Texas Tech's Masked Rider for 2006–2007, is shown at left on the school mascot sidekick, the Midnight Matador. Amy Bell graduated from Kermit High School as valedictorian of the 2003 class. Texas Tech's Masked Rider Program began in 1954 after a long history of volunteer masked riders, who randomly appeared to promote school spirit for the Texas Tech Red Raiders. Amy was officially designated the school's 45th Masked Rider. (Photograph by Artie Limmer, courtesy of Artie Limmer.)

Claxton Hayes (back right) and Jimmy Garcia (back left) coached this Little Dribblers girls' basketball team in the early 1990s. Claxton was a member of the school board for many years and was very active in volunteering for Little Dribblers. Western National Bank of Kermit sponsored this team. (Courtesy of Judy Williams.)

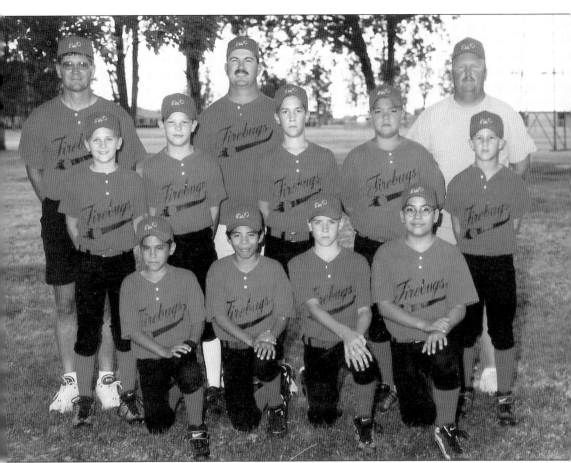

The Firebugs Little League baseball team members are pictured here. From left to right, they are (first row) Michael Madrid, Jonathan Mendoza, Tyler Williams, and Santos Salsado; (second row) Lance Hill, Casey Forga, Taylor Gainey, Lino Rodriguez, and Dewayne McDaniel; (third row) coach Larry Hill, coach Dewayne Forga, and coach Whitey McDaniel. Baseball is a very popular sport in Kermit, beginning with coed T-Ball teams and then moving on to Midget League, then Little League, and finally Pony League. At one time, Kermit even had a semiprofessional baseball team known as the Kermit Oilers. At the end of the season, all of the team coaches get together and pick an All-Star team. The All-Star team will then go on to face other All-Star teams from the same region. Kermit's first Little League All-Star team was formed in 1952. (Courtesy of Judy Williams.)

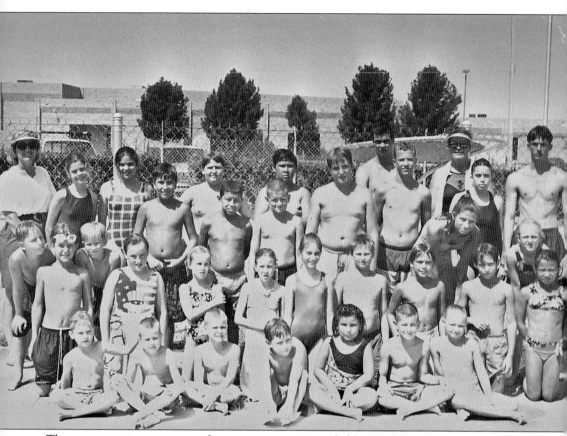

The summer swim team was a free summer sport provided by Winkler County and the Kermit Independent School District. From 10:00 a.m. to 11:00 a.m., Monday through Friday, Kermit's and Wink's youth were allowed to show up at the county swimming pool and join swim team. All ages were allowed to attend up until after graduation. Knowing how to swim was not a prerequisite because swimming classes were also provided. The swim team would have two swim meets during the summer against the team from Jal, New Mexico. They would race one meet in Jal and one meet in Kermit. Other summer sports such as golf and track were also provided free of cost. The picture above shows the Kermit swim team after a meet in the early 1990s. (Courtesy of Judy Williams.)

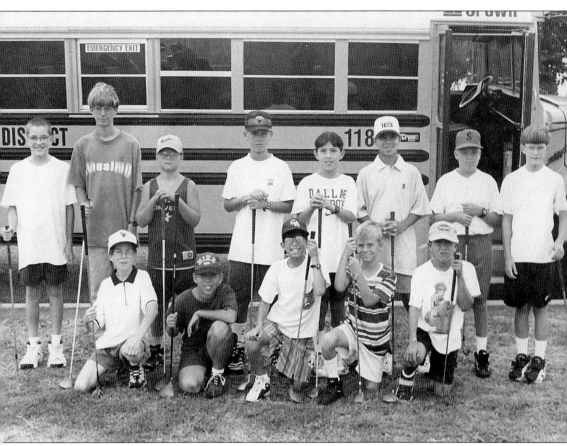

Members of the 1995 summer golf team are shown here getting ready to go play at the Winkler County Golf Course. From left to right are (first row) Dustin Graham, Erik Barrandey, John Paul Barrandey, Tyler Williams, and Harold Lopez; (second row) Coty Simms, Josh Williams, Seth Warden, Justin Wright, Caleb Briones, Desmond Briones, Marshal Buckliou, and an unidentified player. Summer golf was another free summer sport. The golf team would meet from 9:00–10:00 a.m., Monday through Friday, at the junior high lawn. They would work on key golfing techniques such as driving the ball and putting. Instead of a tournament, the golf team would get to take a field trip to the Winkler County Golf Course to play a round of golf every Tuesday. The same rules applied to the golf team; both boys and girls of school age could join. Most of the children who joined the summer golf team played at least one year of golf in junior high, if not more. (Courtesy of Judy Williams.)

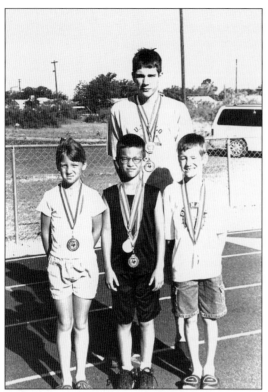

Another summer sport was the summer track team. The track team met 8:00–9:00 a.m., Monday through Friday, at the junior high track. Track was not the most popular summer sport; maybe because it entailed a lot of running. Shown here from left to right are track team members Arlene McDaniel, Brian Sides, and Trent Gainey, along with Kermit High School track athlete Brandon Hartley. (Courtesy of Kaysie Sabella.)

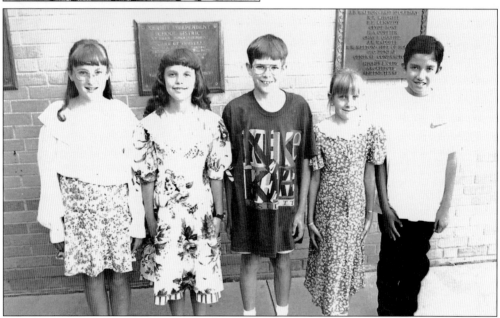

These five students, from left to right, Amy Bell, Natalie Campbell, Brandon Hartley, Kaysie Williams, and Chris Zamora were awarded the fourth grade Superintendent's "A" Honor Roll Award for the school year 1993–1994. Kermit ISD takes pride in the academic success of its students and is always awarding them with "A" and "B" honor roll awards along with K awards. (Courtesy of Kaysie Williams.)

In junior high, little compares to the excitement of the eighth grade prom. The eighth grade prom is an end-of-year dance held before eighth grade graduation. Similar to a senior prom, all of the girls get dressed up. Shown here from left to right are (first row) Alexis May, Stefanie Donica, Kaysie Williams, and Laura Clay; (second row) Lacey LaLonde, Amy Bell, Summer Hayes, and Megan Storres. (Courtesy of Kaysie Williams.)

Shown here from left to right are the 2003 girls junior varsity volleyball team: (first row) Michaela Glander and Misty Barron; (second row) Michelle Wagoner, Quimby Cubine, Shakima Dingle, Megan Briones, and Ashley Garcia; (third row) Beth Fisher, Kaysie Williams, Rebeckah McGonagill, coach Linda Knight, Stephanie Porras, Denise Valenzuela, and Kacey Reynolds. (Courtesy of Judy Williams.)

Members of the 2000 Kermit boys' varsity basketball team are pictured here. From left to right, they are (first row) Juan Muniz, Bradley Wright, Joshua Williams, Brandon Leeson, Justin Myers, and Brandon Hobbs; (second row) coach Jay Cantrell, Michael Alvarado, Cole Barrimore, David Bossett, Brian Duncan, Alan Smithhart, Try Trenchard, Wade Henderson, Brent Adams, Manny Munoz, Rigo Gonzales, and assistant coach Ray Carroll. Missing from the above picture is Michael Combs. The 2000 team had a very successful year, winning district and bi-district. Unfortunately, the team lost during the first round of area play, but winning the Bi-District Championship ranks this team as one of the best Kermit varsity basketball teams. (Courtesy of Judy Williams.)

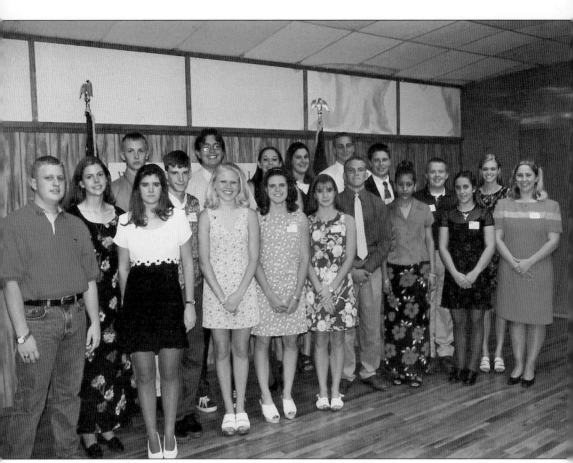

Junior Leadership is a group sponsored by the Kermit Chamber of Commerce. The program is meant to teach leadership skills such as trust and teamwork through a series of tasks and games. Juniors from both Kermit and Wink are allowed to become members as long as they are passing all of their classes. Pictured above is the 1999 Junior Leadership group at their graduation ceremony. From left to right, they are (first row) Zach Armstrong, Laura Bell, Michelle Rushing, Josh Williams, Milisha Myers, Danni White, Leah Berry, Chris Stevens, Priscilla Aguirre, Dinelle Short, and Shana Smith; (second row) Levi Taylor, B.J. Segars, Mandy McCallister, Marci McCallister, Sam Herring, David Clay, Zach Hill, and Destiny Shipley. (Courtesy of Betty Edwards.)

Members of the 2002 seventh grade Kermit Junior High basketball team are shown here from left to right: (first row) Matt Terry, David Carrasco, Albert Gonzales, Josue Muniz, Jay Carrasco, Lance Hill, and Dewayne McDaniel; (second row) Aaron Williams, Bivian Hermasillo, Brady Parks, Ken Baucham, Jacob Bell, Lowell Kyle, Tyler Williams, and Cody Thomas; (third row) Kelly Bradford, Justing Cates, Adam Rios, Cedric Thompson, Jimothy Natividad, Joe Lujan, Frank Zuniga, Jacob Garcia, and coach Shane Saboie. (Courtesy of Judy Williams.)

In 2000, the K Band traveled to Durango, Colorado, for their end-of-year band trip and to participate in a concert competition. The trip included whitewater rafting, a train ride, and a day of visiting in Silverton, Colorado. This picture shows the K Band shortly after performing in the concert competition. The band was under the direction of band director George Swinney. (Courtesy of Kaysie Williams.)

Band members are, from left to right, (first row) Johnathan Horn and Michael Reed; (second row) Dane Preston, Amanda Pando, Eddie Moore, Lacey LaLonde, Brian Harris, Amy Bell, Krystal Carrasco, Alicia Munn, and Beatrice Garcia; (third row) Heather Day, Natalie Campbell, Alexis May, Kaysie Williams, Tiffany Johnson, Jenny Cody, Summer Hayes, Whitney Harrington, Cody Browning, and Nikki Friday; (fourth row) Zach Hill, Joe Percifield, Wayne Holder, Erick Wallace, Josh Williams, Zach Thompson, Johnny Martinez, Matt Leyva, Amy Evans, Jason Forrester, Christina Hammond, Michael Rushing, and Hector Hermisillo. The band members are posed in front of a passenger train in Silverton, Colorado. (Courtesy of Kaysie Williams.)

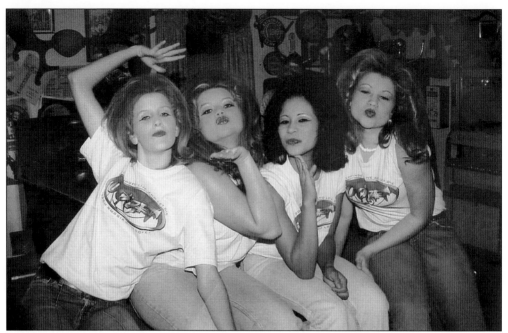

As part of the 2002 K Band marching season, twirling rifles were added to the shows repertoire. The band's theme was James Bond with three selections from the collection of movies. The rifle girls—from left to right, Kaysie Williams, Lacey LaLonde, Ashley Garcia, and Natalie LaLonde—have their hair puffed and applied extravagant makeup in order to look like Bond girls from the early 1970s. (Courtesy of Judy Williams.)

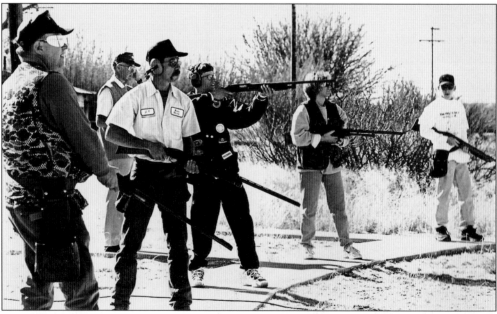

The 4-H is a very popular club in Kermit. One of the many parts of the club is the 4-H trap club. Members of the club can go out to the trap field beside the VFW. Other programs offered by the 4-H are cooking classes and, of course, raising livestock. Participants can raise anything from chickens to rabbits, pigs, goats, and steer. (Courtesy of Judy Williams.)

Homecoming queen is the competition of a lifetime for most senior girls. A candidate can get dressed up and be driven in a nice car through the Homecoming parade, and she becomes queen of the school for a week. Jamarsha Ballard was elected as Kermit's Homecoming queen in 1989. (Courtesy of Jamarsha Ballard.)

The Roughnecks are a youth football organization funded by local businesses. Any boy from grades three through six can participate. The Roughnecks are allowed to play their games at Walton Field, the Kermit High School football field. Seen here is 10-year-old Zathan McIntosh, linebacker for the Roughnecks. (Courtesy of Jamarsha Ballard.)

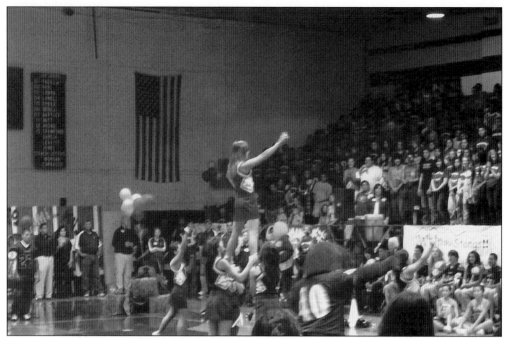

Homecoming week is a weeklong extravaganza, including a bonfire, parade, pep rally, and Homecoming queen announcement, all culminating into excitement for the big Homecoming football game. These pictures were taken at the 2010 Homecoming pep rally located in the gym of the 1951 high school; this pep rally was probably the last pep rally that will be held in that high school because the new high school is set to open in 2011. Students from the junior high are brought over to participate in the pep rally. The junior high cheerleaders get to be included in cheers and dances. (Both, courtesy of Kaysie Sabella.)

Homecoming queen nominees are first nominated by anyone in the school and then voted on by the senior class. There are also freshman, sophomore, and junior class candidates that vie for the crown of their class's princess. There are usually three Homecoming queen nominees; shown above is 2010 Homecoming queen nominee Corina Madrid. (Courtesy of Kaysie Williams.)

Girls are not left out during football season; Winkler County has a youth cheerleaders association. Young girls are allowed to become cheerleaders and cheer for the Roughneck football team. They rode on their own float during the 2010 parade and gave praise to the their sponsors, which included Chance Tool, J and M Cattle, Rapid Transport, B and M Maintenance, and John and Stefanie Haley. (Courtesy of Kaysie Sabella.)

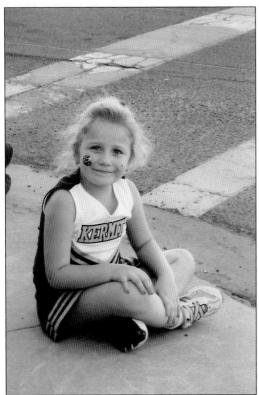

Waiting for the parade to get to one's part of the street can seem like forever. Alyssa Seales, granddaughter of Mike and Martha Fostel, is all dressed up in her Kermit cheerleading outfit and yellow jacket tattoo. Many students wear their Kermit jerseys and cheerleading uniforms to school on football Fridays, but everyone dresses up on Homecoming Friday. (Courtesy of Kaysie Sabella.)

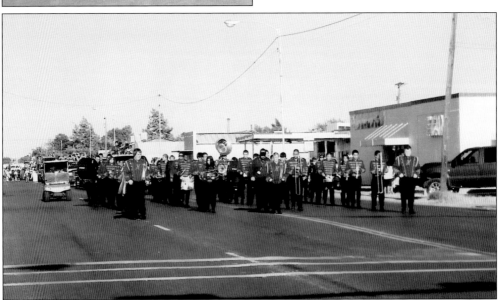

The 2010 Kermit band was led by three drum majors. Seen here from left to right are drum majors Forest Hanson, Cheryl Jones, and Michael Vargas leading the Homecoming parade. As Kermit's population has decreased, so has the size of the band. Quite a bit smaller than the 120-piece band that band director G.T. Gilligan began, the 2010 K Band still puts their best foot forward, winning a Division 1 in a marching contest in 2010, directed by Timothy Hickman. (Courtesy of Kaysie Sabella.)

BIBLIOGRAPHY

Smith, Julia Cauble. "Winkler County." *Handbook of Texas* Online, http://www.tshaonline.org/handbook/online/articles/WW/hcw13.html (accessed October 12, 2010).

Texas Historical Commission Online, http://atlas.thc.state.tx.us/index.asp (accessed August 10, 2010).

Winkler County Historical Commission. *Winkler County 1887–1984*. Lubbock, TX: Specialty Publishing Company, 1984.

www.arcadiapublishing.com

Discover books about the town where you grew up, the cities where your friends and families live, the town where your parents met, or even that retirement spot you've been dreaming about. Our Web site provides history lovers with exclusive deals, advanced notification about new titles, e-mail alerts of author events, and much more.

Find Your Place in History.